A CARAVAGGIO REDISCOVERED

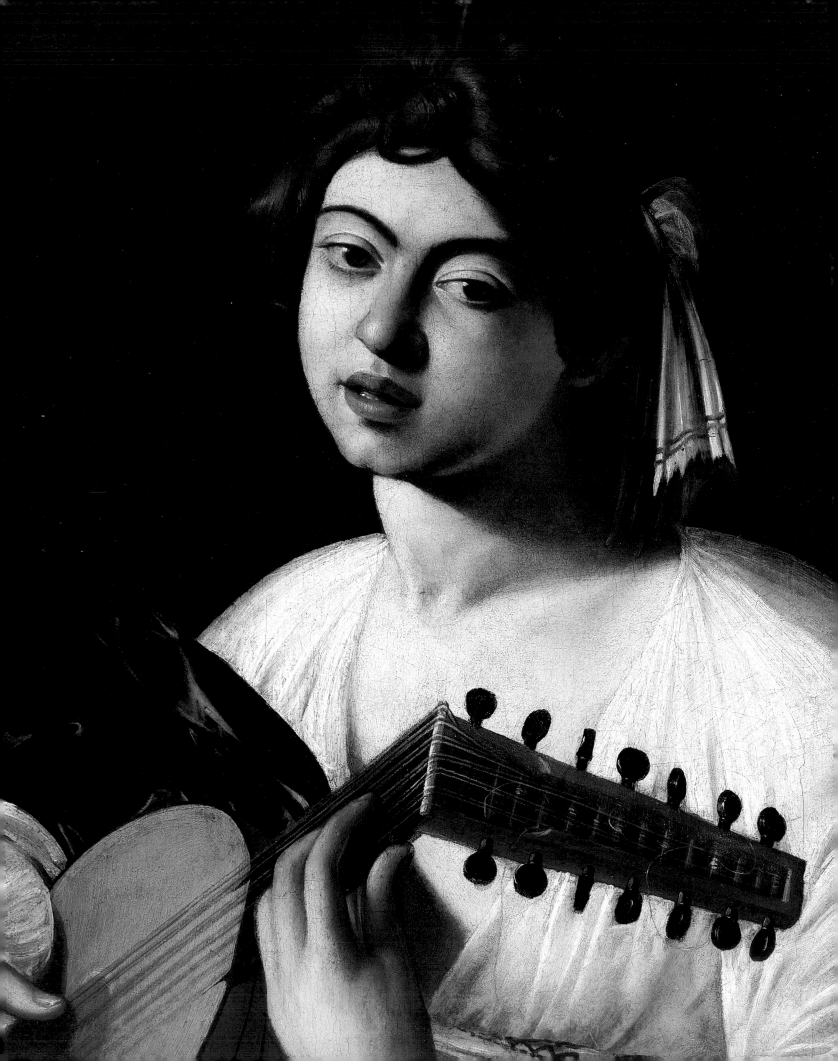

A Caravaggio Rediscovered
THE LUTE PLAYER

KEITH CHRISTIANSEN

THE METROPOLITAN MUSEUM OF ART
NEW YORK

This publication was issued in conjunction with an exhibition held at The Metropolitan Museum of Art from February 9, 1990, to April 22, 1990.

Copyright © 1990 The Metropolitan Museum of Art

Published by The Metropolitan Museum of Art, New York
John P. O'Neill, Editor in Chief
Kathleen Howard, Editor
Bruce Campbell, Designer
Gwen Roginsky, Production Manager

Typeset in Garamond by U.S. Lithograph, typographers, New York
Printed on 100 lb. Warren's Lustro Offset Enamel
Separations made by Professional Graphics, Inc., Rockford, Illinois
Printed and bound by Colorcraft Lithographers, Inc., New York

Cover, frontispiece, and p. 8: Details of Caravaggio's *Lute Player* (private collection, New York; cat. 5).

Photo credits—cat. 4: Araldo de Luca, Rome; cat. 5: Bruce White, Metropolitan Museum Photograph Studio; all other photographs supplied by institutions cited in captions.

Library of Congress Cataloging-in-Publication Data
Christiansen, Keith.
 A Caravaggio rediscovered, The Lute Player/Keith Christiansen,
 p. cm.
 Includes bibliographical references.
 ISBN 0-87099-575-8
 1. Caravaggio, Michelangelo Merisi da, 1571–1610. Lute player—
Exhibitions. 2. Caravaggio, Michelangelo Merisi da, 1571–1610—
Exhibitions. I. Metropolitan Museum of Art (New York, N.Y.)
II. Title.
ND623.C26A67 1990 89—13855
759.5—dc20 CIP

Contents

Foreword

This exhibition inaugurates the extended loan to the Metropolitan Museum of a newly identified painting by Caravaggio, *The Lute Player*, one of the artist's best-known works in seventeenth-century Rome. Curiously, the picture has been almost completely ignored by modern scholars, and those few who have discussed it have viewed it as a copy of a better-known, earlier variant composition in the Hermitage, Leningrad. However, recently published documentation now establishes its authorship and provenance beyond any doubt. Painted for Cardinal Francesco Maria del Monte, Caravaggio's major patron and discoverer, the picture is shown here—together with other works by Caravaggio—for the first time since its sale in 1948 from the Barberini collection, Rome. Of the other paintings by Caravaggio in the exhibition, three were, like *The Lute Player*, painted for Cardinal del Monte, while the fourth, the picture in Leningrad—perhaps the masterpiece of Caravaggio's early style—was destined for the Marchese Vincenzo Giustiniani, the artist's other major patron in Rome. Taken together, these pictures constitute the most important group of secular works by the artist ever assembled and provide a unique occasion to evaluate both Caravaggio's development as an artist and the importance of Cardinal del Monte as a patron and a collector.

Surprisingly, only one of these paintings, *The Musicians*, appeared in *The Age of Caravaggio*, held at the Metropolitan Museum and at the Museo Nazionale di Capodimonte in Naples in 1985. This was not the result of oversight on the part of the organizers of that exhibition, the most comprehensive of the last thirty-nine years. Rather, the present exhibition reflects changes that have resulted in part from that signal event. In 1985 *The Cardsharps* was known only through copies (the original appeared in 1987 and was exhibited at the Metropolitan following its acquisition by the Kimbell Art Museum, Fort Worth, and its cleaning and restoration at the Metropolitan). *The Fortune Teller* was considered a copy by many; the cleaning in 1984–85, which prevented its inclusion in *The Age of Caravaggio* (although it appeared in the catalogue), vindicated Caravaggio's authorship. Thus, this exhibition is in a real sense an update and a corrective to *The Age of Caravaggio*.

No less significant than the appearance and reidentification of "new" pictures by Caravaggio are some developments—really advances—in our understanding of the cultural milieu in which he worked in Rome and of the meaning that underlies some of his most familiar early masterpieces. One such advance is the subject of the second part of the exhibition, which investigates music and musical practice and patronage in late sixteenth- and early seventeenth-century Italy through paintings and prints. Also included are musical instruments of the period similar to those in the paintings (these have been drawn from the Metropolitan's comprehensive collection).

We are extremely grateful to the lenders to this exhibition for their interest and generosity, as well as to the donor who has underwritten it. Special thanks are due the staff of the Hermitage for the exceptional loan of their *Lute Player*, thus providing a rare occasion for comparing the two related but highly individual variants of one of the artist's most memorable inventions.

Philippe de Montebello
Director
The Metropolitan Museum of Art

Acknowledgments

In writing this catalogue I have been painfully aware of the deficiencies in my knowledge of Caravaggio. For this reason I am especially grateful for the help and advice of friends and specialists—above all Sir Denis Mahon, whose interest and participation in this project have been as great as my own. He was directly responsible for reidentifying the picture that is the focus of the exhibition, and he has kindly read the text of the catalogue in manuscript form, catching errors of fact and fancy. Scarcely less thanks are due Franca Trinchieri Camiz, whose work on Caravaggio, Cardinal del Monte, and music is the basis of most of the ideas presented here. She has answered numerous queries with her characteristic generosity. I should also like to record my debt to Mina Gregori, who has been, with Denis Mahon, my mentor in Caravaggio studies. Andrea Bayer and Laurence Libin assisted at all stages, making this very much a collaborative project. Andrea Malvezzi undertook a variety of tasks, offering indispensable advice about the translation of musical texts.

This exhibition has been organized in an unusually short period of time, and I am especially grateful to the lending institutions and their staffs for exceptional efforts to comply with requests. Among the many individuals I should mention for a variety of favors are Joseph Baillio, Susan Barnes, Richard Bretell, David Brown, Terrence Ford, Marilyn Lavin, Mark Leonard, Christopher Lloyd, Patrick Matthiesen, Charles Moffett, Lawrence Nichols, Edmund Pillsbury, Joseph Rishel, Colin Slim, Richard Spear, Claudio Strinati, Peter Sutton, Gregory Thompson, Elisa Tittoni, Svetlana Vsevolzhskaya, John Walsh, and Ruth Yeaman. At the Metropolitan special thanks are due Mahrukh Tarapor, as well as Linda Sylling, Emily Rafferty, and Herb Moskowitz, without whose help the exhibition would not have taken place. I am also grateful to David Harvey, who was in charge of its design, and to Suzanne Boorsch, Barbara Bridgers, Bruce White, and Mindell Dubansky. John P. O'Neill saw to it that the catalogue received the expert attention of Kathleen Howard, Bruce Campbell, and Gwen Roginsky. As always, I am indebted to the members of the Department of Paintings Conservation and in particular to Gisela Helmkampf, who carried out the restoration of *The Lute Player*, and to Charlotte Hale.

Keith Christiansen
Jayne Wrightsman Curator
Department of European Paintings

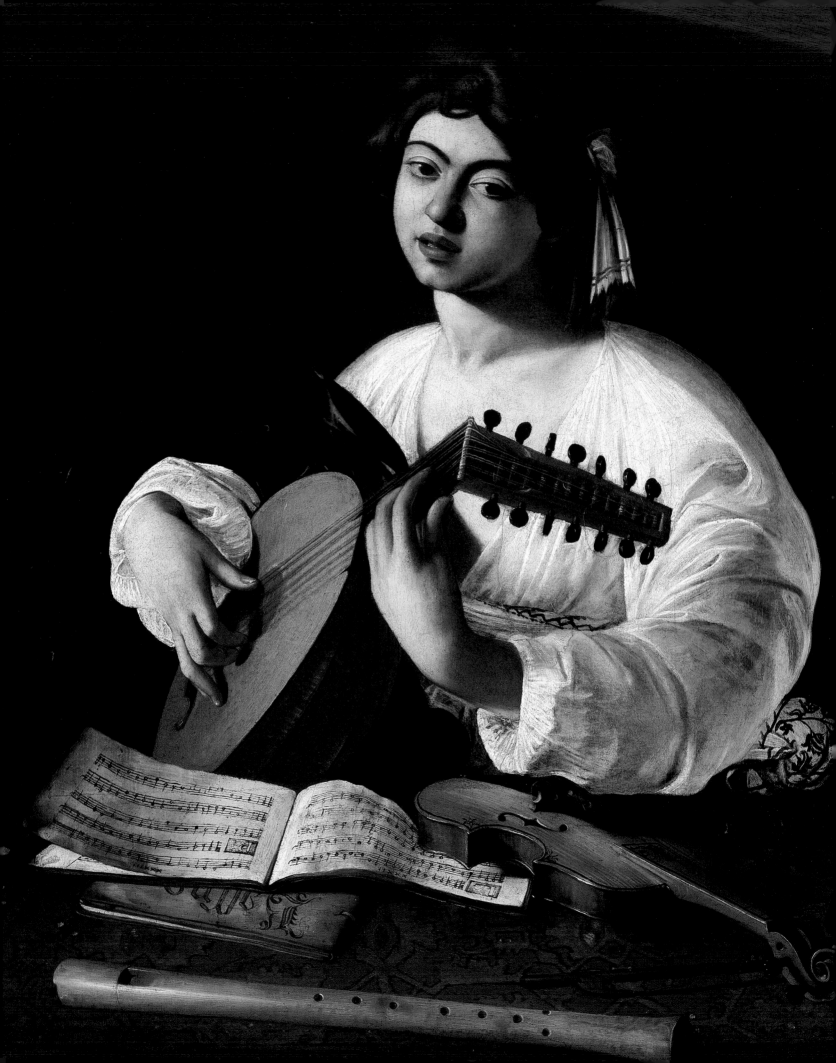

A CARAVAGGIO REDISCOVERED:
THE LUTE PLAYER

KEITH CHRISTIANSEN

In sixteenth-century Rome an artist's career did not take wing when he left his teacher's workshop to set up his own independent practice or when his pictures began to attract occasional buyers from dealers taking advantage of the dilettante collector, on the one hand, and the products of young, struggling artists, on the other. Rather, success came when a high-placed figure—a prelate or a member of one of the old aristocratic families with established connections—took a young artist under his protection, introduced him into his circle of friends and associates, and secured what every aspiring talent longed for: a commission for an altarpiece or cycle of frescoes in a major Roman church. Only in this way could a painter's work gain the public exposure and critical attention on which, then as now, success depends. For Caravaggio this turn of events occurred about 1595, when a picture of his was purchased from a dealer near San Luigi dei Francesi by one of the dominant figures in the Rome of Pope Clement VIII, Cardinal Francesco Maria del Monte (1549–1626; fig. 1), who lived in the neighborhood.[1]

Caravaggio (1571–1610) had arrived in Rome from his native Lombardy sometime after May 1592, unknown and without a single major picture to his credit. One rumor had it that he fled Milan following an altercation, but he may simply have been seeking a larger arena for his untried but considerable ambition.[2] His first two years in the city were miserable. For a time he was reduced to painting copies of devotional pictures for a beneficiary of Saint Peter's (a task for which few artists can have been more ill-suited). His attempts to set up shop with other young artists ended in failure, and the eight months he reputedly spent with his scarcely older but highly successful contemporary, Giuseppe Cesari, the Cavalier d'Arpino (1568–1640), must have been humiliating for an artist of his fiercely independent temperament. Arpino is said to have set him to painting flowers and fruit —the sort of task a painter from north Italy was presumed to excel at. It is likely that Caravaggio also created a number of small pictures, semiallegorical-semigenre in character, for sale to Arpino's many clients. Two of these—one showing a boy with a basket of fruit, the other a youth (probably Caravaggio himself) with the attributes of Bacchus—were still in the possession of Arpino in 1607 and were sequestered by the Borghese Pope Paul V together with the contents of Arpino's studio (they are now in the Galleria Borghese, Rome).[3]

Shortly after Caravaggio left Arpino's workshop, the most ambitious of his early pictures—*The Cardsharps* (Kimbell Art Museum, Fort Worth)—was purchased by Cardinal del Monte (we are told so by Giovan Pietro Bellori, Caravaggio's most authoritative seventeenth-century biographer). The cardinal seems to have been greatly impressed with the

work, for there followed an invitation to take up quarters in his residence in Palazzo Madama and the promise of a stipend. The event marked a turning point: Giovanni Baglione, Caravaggio's early biographer and rival painter, describes the boost to his spirits the invitation effected after so many false starts and reversals. The years spent with Del Monte, from roughly 1595 to 1600, were crucial to Caravaggio's career and his development as an artist.[4]

Del Monte was a well-known and respected figure in Roman art circles. In 1593 Cesare Ripa had dedicated the first edition of his manual of iconography to the cardinal and included an encomiastic passage in later printings. And when, in 1596, Cardinal Federico Borromeo vacated his position as protector of the painters' academy, the Accademia di San Luca, Del Monte and Cardinal Gabriele Paleotti were appointed in his stead. Del Monte retained this position until his death, taking an active role in the academy.[5] His connections

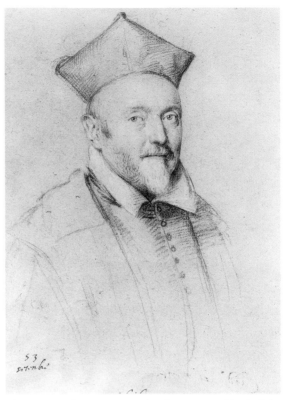

Fig. 1. Ottavio Leone, *Cardinal Francesco Maria del Monte.* John and Mable Ringling Museum of Art, Sarasota, Florida.

with the Florentine court of Grand Duke Ferdinando I de'Medici, to whom he was obliged for his ecclesiastical position and in whose palace he lived, and his overriding passion for music placed Del Monte in the inner circles of papal Rome. It was through Del Monte, directly or indirectly, that Caravaggio's work became known to a powerful elite: the Marchese Vincenzo Giustiniani, who not only wrote a short treatise on painting but was also one of the most perspicacious collectors in Rome (at his death he owned no fewer than thirteen pictures ascribed to Caravaggio); Cardinal Federico Borromeo, the reforming archbishop of Milan, who owned Caravaggio's still life of a basket of fruit (Pinacoteca Ambrosiana, Milan); Grand Duke Ferdinando de'Medici, to whom Del Monte sent at least two pictures by Caravaggio as gifts; Ciriaco Mattei, to whose family palace Caravaggio moved in 1601 and whose son bequeathed to Del Monte the *Saint John the Baptist in the Wilderness* now in the Pinacoteca Capitolina, Rome; and probably also the bankers Ottavio Costa and Laerzio Cherubini (like Giustiniani, a neighbor of Del Monte and the patron of *The Death of the Virgin*, now in the Louvre).[6] It was Del Monte who, in 1599, secured Caravaggio's crucial first public commission: the two canvases of the Calling and Martyrdom of Saint Matthew in San Luigi dei Francesi.

This was not the only occasion on which Del Monte took a keen interest in a young artist's career. In 1582 the Duke of Urbino's agent in Rome consulted with him about the

training of a certain youth; Del Monte recommended a program of copying and studying with an excellent master—Scipione Pulzone is singled out—and he actually provided a picture attributed to Raphael from his own collection as a model.[7] And a decade and a half after providing Caravaggio with quarters in his residence, Del Monte became the protector of the remarkably precocious Andrea Sacchi (1599–1661), then barely ten years old, eventually securing him a coveted commission for an altarpiece in Saint Peter's.[8] He was able to do this through his position in the newly reformed Congregazione della Fabbrica which supervised work in the basilica. A perusal of the 1627 inventory of his collection[9] is revealing, for in addition to pictures by such peripheral but popular artists as Antiveduto Grammatica and Alessandro Turchi, he owned a Martyrdom of Saint Catherine by Annibale Carracci,[10] an early Saint Jerome by Guercino,[11] four pictures by Guido Reni,[12] a Penitent Magdalen by Ribera, *The Parable of Dives* by Carlo Saraceni (Pinacoteca Capitolina, Rome), a Herodias and a Supper at Emmaus by the Neapolitan Caravaggesque artist Battistello Caracciolo, and a candle-lit genre scene by the Dutch Caravaggesque painter Gerrit van Honthorst, to say nothing of the numerous landscapes by Jan Brueghel the Elder, Paul Bril, and Filippo Napolitano and two small pictures by that rarest of artists, Adam Elsheimer, which were framed with protective covers.

At his death in 1626, Del Monte owned a total of eight works by Caravaggio: *The Fortune Teller* (Pinacoteca Capitolina, Rome; fig. 6), *The Cardsharps* (Kimbell Art Museum, Fort Worth; figs. 2–4), *The Musicians* (Metropolitan Museum of Art; figs. 8 and 9), an Ecstasy of Saint Francis (in the past usually identified with the picture in the Wadsworth Atheneum, Hartford[13]), a still life of a vase of flowers (lost), *Saint Catherine of Alexandria* (Thyssen Collection, Lugano; fig. 25), *Saint John the Baptist in the Wilderness* (Pinacoteca Capitolina, Rome), and *The Lute Player* (figs. 19–21) discussed in these pages. Additionally there was the painted ceiling in a small room of Del Monte's villa[14] as well as copies of a Saint Matthew and of a Doubting Thomas (the original of the latter belonged to Vincenzo Giustiniani and is now in the Staatliche Schlösser und Gärten, Potsdam; the former may have been a reduced copy of the large altarpiece also owned by Giustiniani). Except for the copies and the *Saint John the Baptist*, all the pictures were painted prior to 1599, during Caravaggio's residence with the cardinal, and in them the Lombard painter's idiosyncratic genius emerges with remarkable clarity.

The importance of Del Monte's pictures and of his influence on Caravaggio's development has long been recognized. However, a full appraisal had been hindered by the loss of a key work, *The Cardsharps* (which only reappeared on the art market in 1987, after a lapse of almost ninety years; see cat. 2); the questioned attribution of a second, *The Fortune Teller* (which a 1984–85 cleaning confirmed as an autograph work; see cat. 1), and the misidentification of a third, *The Lute Player* (long confused with a painting of the same subject and related composition in the Hermitage Museum, Leningrad, that belonged to the Marchese Vincenzo Giustiniani, Caravaggio's other great patron; see cat. 5). The recovery of these works opens a new chapter in Caravaggio studies.

Of the three pictures, the most famous and influential was *The Cardsharps* (fig. 2), of which more than thirty copies are known.[15] Purchased by Cardinal Antonio Barberini following the death of Del Monte, it was studied by Bellori in Barberini's palace near the Campo dei Fiori. Bellori was not an admirer of Caravaggio—he championed an idealist conception of art at odds with the realistic premise of Caravaggio's work—but few critics possessed his analytic powers, and his description of *The Cardsharps* deserves to be quoted in full. It follows a brief discussion of two other early works by the artist: *The Penitent Magdalen* and *The Rest on the Flight into Egypt* (both in the Galleria Doria-Pamphilj, Rome): "[Caravaggio] showed a simple boy with cards in his hand, his head copied from life very well, wearing dark clothes, and opposite him a fraudulent youth in profile who with one hand leans on the game table and with the other takes a trick card from his belt, while a third [figure] near the boy observes the markings of the cards and with three fingers signals his companion, who, in leaning over the table displays to the light his yellow jacket with black stripes; nor is the color untrue to life. These are the first works from Caravaggio's brush, painted in that straightforward manner of Giorgione, with tempered shadows."[16]

Bellori's comments on the style of Caravaggio's early pictures reflect a century-old tradition crediting the great Venetian Giorgione with the creation of a naturalistic style that achieved its effects through a reliance on color and the imitation of nature rather than through the central Italian emphasis on drawing, theory, and the study of ancient art. We would now draw a further distinction between north Italian–Lombard painting and Venetian art proper, but Caravaggio's contemporaries tended to view the products of these two neighboring regions as manifestations of the same bias. Even to so perspicacious an observer as the early seventeenth-century prelate and writer Giovanni Battista Agucchi—who acknowledged the existence of a Lombard school—the difference seemed a matter of degree rather than kind. In his influential treatise, of primary importance to later critics like Bellori, he observed that just as there had been four styles of painting in antiquity, so in his own day there were four schools of Italian painting: the Roman, which "followed the beauty of sculpture and approached the artifice of the ancients"; the Venetian and Marchigian, which "have, rather, imitated the beauty of nature as presented to the eye"; the Lombard, led by Correggio, "who was an even greater imitator of nature"; and the Tuscan, with its concern for detail, diligence, and display of artifice.[17] Inevitably, in Rome Caravaggio was stereotyped as a Lombard or, more simply, a north Italian artist, and the sort of work he initially undertook was a function of this narrow perception. While Agucchi acknowledged Caravaggio's mastery of color, he criticized the artist's dependence on the visible world—which to a Platonic-minded critic like himself gave only an imperfect idea of a higher, abstract reality. Typically, at the unveiling of Caravaggio's canvases in San Luigi dei Francesi, Federico Zuccari, the doyen of Roman artists, is reported to have exclaimed, "What's all the fuss about? I see nothing here beyond Giorgione's conception of painting."[18]

Del Monte seems to have had a keen appreciation for this north Italian–Venetianizing style. Though of a Marchigian family, he was born and baptized in Venice—Titian, Sansovino,

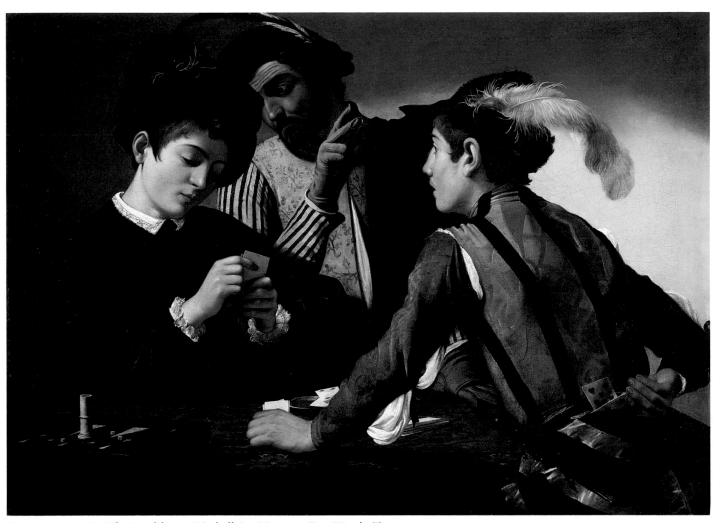

Fig. 2. Caravaggio, *The Cardsharps*. Kimbell Art Museum, Fort Worth, Texas.

Overleaf:
Figs. 3 and 4. Details of fig. 2.

13

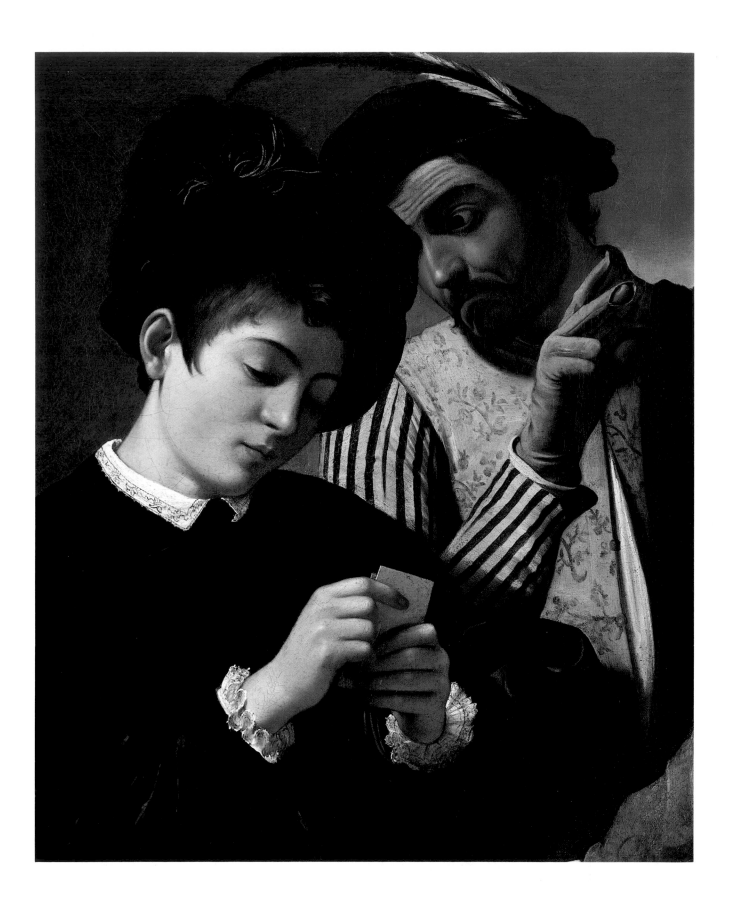

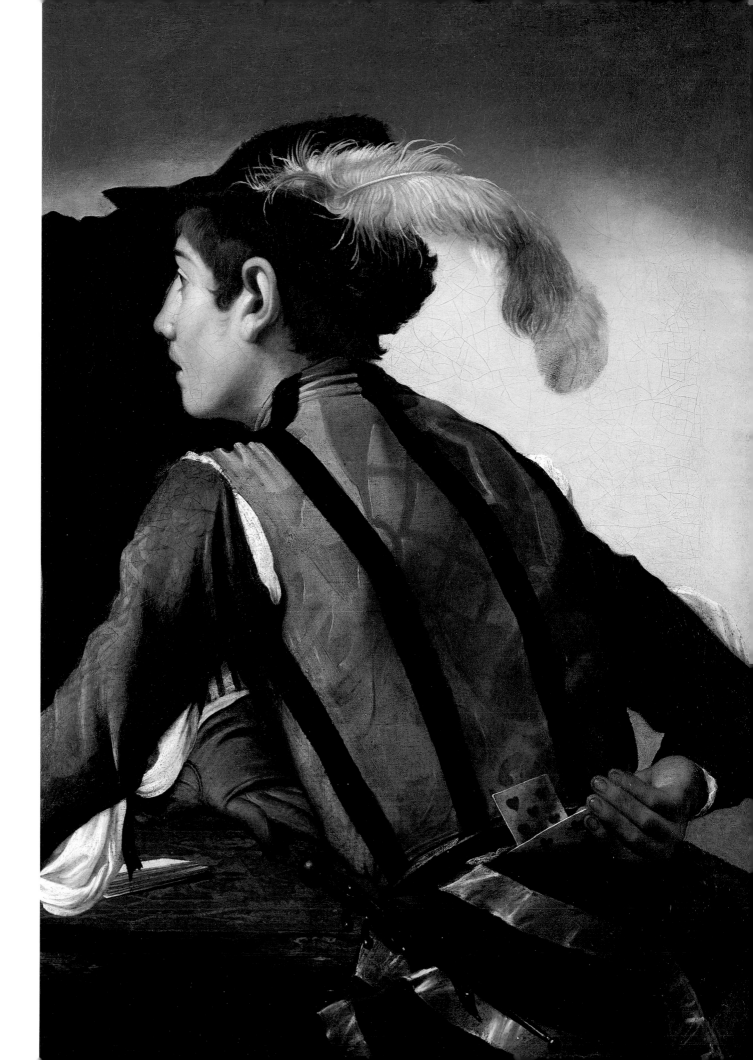

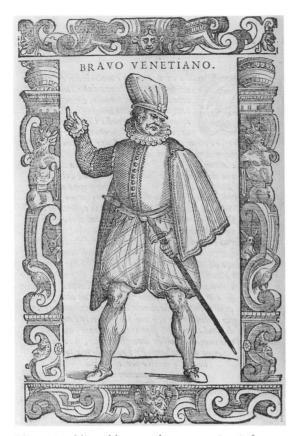

Fig. 5. A soldier of fortune (*bravo venetiano*), from Cesare Vecellio 1590, p. 164v.

and Aretino are reported to have witnessed his christening—and at the court of Urbino, by which his father was employed and where he was educated, Venetian art was highly prized.[19] Del Monte's extensive collection contained the obligatory pictures and cartoons ascribed to the great names of central Italian art—Michelangelo, Raphael, Leonardo, and Andrea del Sarto[20]—but there were also four paintings ascribed to Titian, including a version of the well-known Penitent Magdalen, a portrait by Palma Vecchio, two works by Bassano,[21] three by Bernardino Licinio,[22] and a picture that was believed to be by Giorgione himself.[23] Del Monte's patronage of Caravaggio—this new Lombard practitioner of "Giorgionesque" painting—may therefore stem from a genuine bias for Venetian style; it was certainly encouraged by the well-established habit in Rome of supporting artists from one's own region: Caravaggio's teacher in Milan, Simone Peterzano, had, after all, been a pupil of Titian. Del Monte's support of a new naturalism in the arts is further attested by his admiration for the work of Scipione Pulzone, with its almost northern concern for detailed description, and by the terms in which, in 1599, he commended the work of a young artist in his employ to Christine of Lorraine, the wife of Ferdinando de'Medici.[24]

Such considerations should not, however, overshadow the significance of Del Monte's invitation to Caravaggio and his acquisition of a second, even earlier painting showing a gypsy fortune teller surreptitiously slipping the ring from the finger of a youth whose palm she is reading (fig. 6). To Bellori, this picture (or rather, the second, later version of it now in the Louvre) was little more than a demonstration of the mimetic goals of Caravaggio's art, achieved at the expense of the example of antiquity and the High Renaissance. He recounts that when Caravaggio was shown the most famous ancient statues in Rome as worthy models for his art, his response was to invite a gypsy into his studio and paint her telling the fortune of a youth. Bellori, of course, viewed Caravaggio's work from a distance of three-quarters of a century and through the distorting lens of numerous lowlife scenes inspired by it. However, when Del Monte purchased *The Cardsharps* and *The Fortune Teller*, their subjects were as novel as their style. So far from being simple demonstrations of mimesis—paintings as *tranches de vie*—they employed recognizable types and familiar

situations to make a quasi-didactic, moralizing point about deception and the credulity of youth. This intent linked them to a category of painting that Del Monte's associate at the Accademia di San Luca, Cardinal Gabriele Paleotti, had termed *pitture ridicole* in his 1582 discourse on painting: pictures that instruct by ridiculing foolish behavior.[25] However, the works Paleotti probably had in mind relied, for the most part, on an extensive use of emblems and parody. Caravaggio's approach, at once disarmingly direct and richly allusive, was a radical departure, brought out in a 1603 madrigal on *The Fortune Teller* by Gaspare Murtola:

> I don't know which is the greater sorceress:
> the woman who dissembles,
> or you, who painted her.
> She with her sweet spells
> ravishes our hearts and blood.
> You have painted her so that she seems alive;
> so that, living and breathing, others believe her.[26]

The ability to convey meaning by seducing the viewer into accepting a picture as the equivalent of a real experience rather than as an abstracted statement lies at the heart of Caravaggio's art, and it placed him at odds with the art establishment of his day. Nonetheless, even a later, classically biased critic like Bellori realized that this novel approach required not only technical mastery but also a command of costumes and the ability to describe human character. In *The Cardsharps* the wily figure to the right (fig. 4) is identified as a soldier of fortune, or bravo, by the clothes he wears. These closely match the illustrated description (fig. 5) in Cesare Vecellio's manual of costumes (Venice, 1590), where it is stated that "these *bravi* or *sbricchi*... wear on their heads high hats of velvet or silk... with a jacket of Flemish cloth and stitched sleeves.... They frequently vary their dress, and are always dueling.... They serve this or that [master] for money, swearing and bullying without provocation, and committing all kind of scandals and murders."[27] In Caravaggio's picture the bravo sports a parrying dagger (*pugnale*), which he wears on his left rather than his right hip, since he carries no sword. Caravaggio, who enjoyed the role of the street brawler himself, must have been familiar with these youths. In his 1565 compendium of gambling practices, Giovanni Cardaro warned against gambling with such types, noting that they always won "because of their greater experience, trickery, and skill."[28] In contrast to the brash clothes of this streetwise young sharp is the velvet finery of his victim, an empty-headed pretty boy (fig. 3). The cunning accomplice wears torn gloves and mismatched vest and sleeves that define his social status as effectively as does his comical face, with its exaggerated, almost masklike expression (among Caravaggio's earliest and not altogether successful attempts to depict a fleeting emotion). The picture was intended to be read as a staged scene involving clearly differentiated characters enacting an episode from everyday life, and there can be little doubt that for both *The Cardsharps* and *The Fortune*

Fig. 6. Caravaggio, *The Fortune Teller*. Pinacoteca Capitolina, Rome.

Fig. 7. Simon Vouet, *The Fortune Teller.* National Gallery of Canada, Ottawa.

Teller Caravaggio drew inspiration from the conventions of popular theater and such stock characters as the bravo Capitano Spavento. He did, however, conspicuously avoid the element of burlesque that was part of the commedia dell'arte tradition and that was frequently taken up by his later imitators in their treatment of the same themes. In Simon Vouet's *Fortune Teller* (National Gallery of Canada, Ottawa; fig. 7), for example, the comic element of the scene has been heightened through the addition of two characters, one of whom fleeces the gypsy while the other mocks the credulity of her well-dressed customer. The manner in which the latter looks out at the viewer enhances the theatrical character of the picture.

While the theater was one source for Caravaggio, another was northern prints. He would appear to have studied Holbein's woodcut illustration to the *Dance of Death* showing three quarreling gamblers beset by Death and the Devil.[29] However, unlike Holbein and other northern artists, Caravaggio was not interested in condemning gambling as a vice but in exploiting it to expose human foibles. The ostensible message of *The Fortune Teller* is as uncomplicated as that inscribed on a later print by Jacques Callot from his gypsy series: "You who take pleasure in [gypsies'] words, watch out for your dollars and dimes." But he has endowed that admonition with a psychological dimension of compelling complexity.

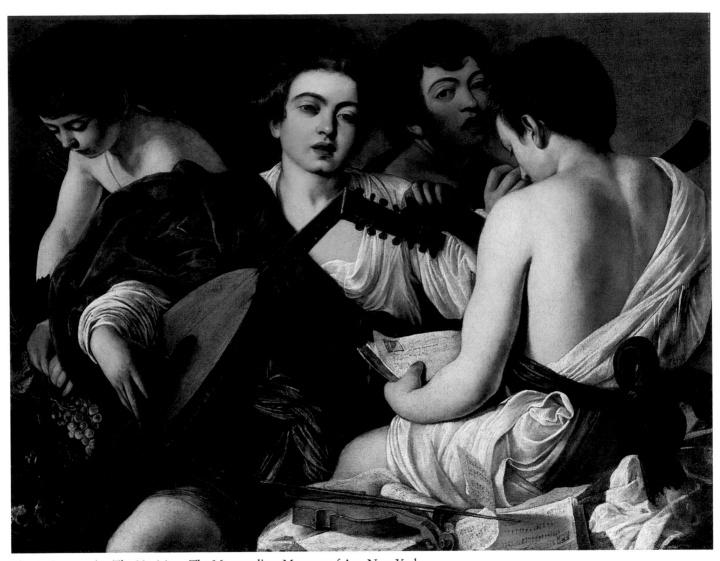

Fig. 8. Caravaggio, *The Musicians*. The Metropolitan Museum of Art, New York.

Fig. 9. Detail of fig. 8.

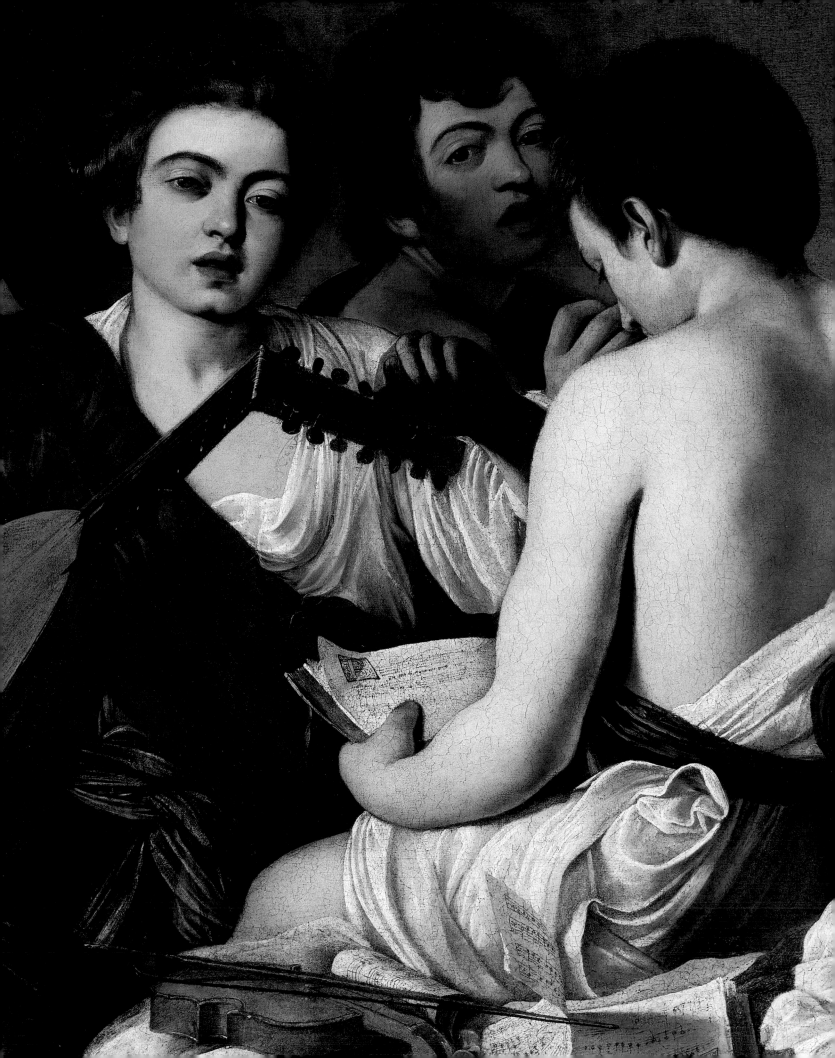

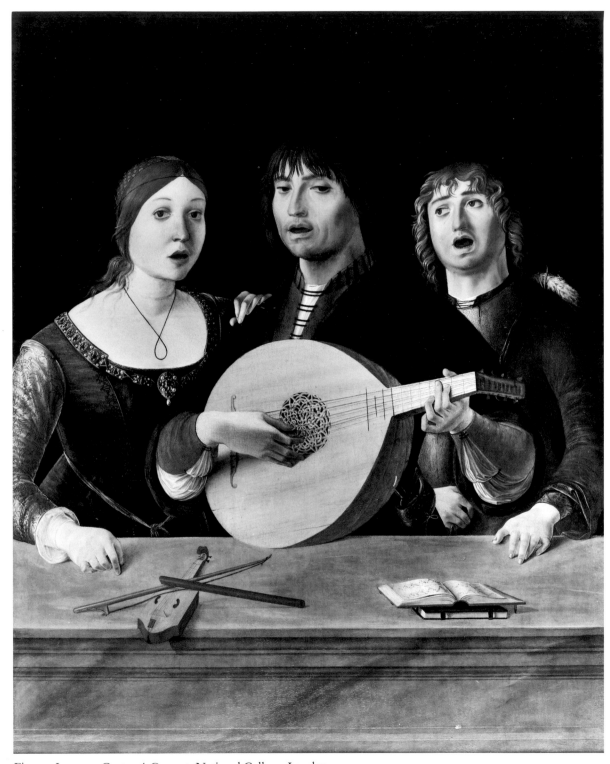

Fig. 10. Lorenzo Costa, *A Concert*. National Gallery, London.

Caravaggio's early pictures were painted for the open market, and both their subject and style were intended to appeal to a wide audience. It is notable that following his move to Palazzo Madama, he painted only two further lowlife pictures: a variant of *The Fortune Teller* (Musée du Louvre, Paris) and a painting of a charlatan pulling the tooth of a peasant to the amusement of onlookers (Galleria degli Uffizi, Florence).[30] *The Tooth Puller* is a late work, conceivably painted in Malta in 1609, and confirms that Caravaggio did not entirely lose interest in these moralizing, "comic" pictures based on everyday life. However, once he moved to Del Monte's residence, a new challenge presented itself: that of satisfying the tastes of a sophisticated elite.

Del Monte's first commission was for a concert scene: *The Musicians* (Metropolitan Museum of Art; fig. 8).[31] This was one of several pictures Caravaggio carried out for Del Monte and his circle of friends that deal with a musical theme or include musical scores, and it is among the first in which Caravaggio confronted the problem of adapting his naturalistic style to the exigencies of an allegorical rather than a moralizing subject.

Concert scenes were a peculiarly north Italian–Venetian genre with a history extending back to the late fifteenth century and encompassing a variety of traditions.[32] Among the earliest are group portraits like Lorenzo Costa's picture showing a woman and two men singing a polyphonic madrigal to the accompaniment of a lute (National Gallery, London; fig. 10). Before them, on a marble parapet, are propped a part-book, a recorder, and a rebec. According to Vasari, Costa decorated a room in the ducal palace at Mantua with, among other elements, a depiction of Isabella d'Este and members of her court "who, singing variously, make sweet harmony."[33] Harmony is clearly the dominant theme of the London picture, which dates from the 1480s, and in a number of sixteenth-century portraits showing several generations of a single family, the performance of music serves as a metaphor for familial harmony.[34] Even when portraiture was not the aim, it determined the realistic vocabulary of most north Italian concert scenes, as in the wonderfully evocative picture by Callisto Piazza (Philadelphia Museum of Art; fig. 11), whose work in and around Milan and Brescia Caravaggio certainly knew. The one type of concert scene to adopt an idealized rather than a realistic approach was the Venetian allegory of Music. This usually shows three classically draped female figures playing musical instruments in the company of Cupid, thus signifying the association of Love and Music. (In Veronese's well-known allegory of Music for the Biblioteca Marciana, Venice, Cupid is shown wingless to signify, according to Vasari, "that he never parts company with [Music]."[35])

It is not known what sort of picture Del Monte expected from Caravaggio, but in *The Musicians* he got a curious and not altogether successful amalgam, even allowing for the painting's present ruinous state that has deprived it of any of the surface refinements of *The Cardsharps*. Three youths, whose loose-fitting blouses have been arranged to evoke without actually describing ancient dress, are shown preparing for a performance: one studies the part-book from which he will sing, another tunes his lute, and the third, usually identified as a self-portrait, turns from his cornetto to gaze at the viewer. A violin and an open part-

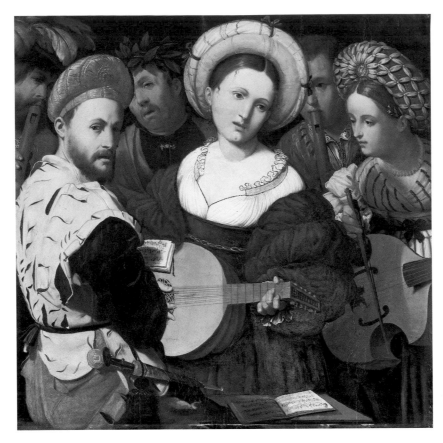

Fig. 11. Callisto Piazza da Lodi, *A Concert*. John G. Johnson Collection, Philadelphia Museum of Art.

book for another piece lie on the cloth-covered ledge that defines the picture plane. The figure of Cupid identifies the subject as an allegory of Music, and the grapes he gathers—a Bacchic motif—underscore this. In his *Iconologia* (the first edition of which, dedicated to Del Monte, predates this picture by only two or three years), Ripa notes that in representations of Music "wine is present, since music was created to make spirits light, just as wine does, and also good, delicate wine aids the melody of the voice, for which reason ancient writers said that they belong in the company of Bacchus."[36] Caravaggio's picture then is an allegory of Music, but it is conceived in terms of the north Italian tradition of concert scenes with which he was familiar.

Even the artist's contemporaries seem to have been unsure exactly how to interpret the picture. Baglione, for example, describes it simply as "a concert of youths painted from life extremely well."[37] The picture's ambiguity is well illustrated by two paintings by Pietro Paolini, a follower of Caravaggio from Lucca (cat. 13 and 14). In one a company of musicians dressed as disciples of Bacchus sings to the accompaniment of the lute and a flute played by Bacchus himself, his head wreathed in grapes and vine leaves. To the right a youth displays a bunch of grapes next to a flute—a juxtaposition whose significance is analogous to that in *The Musicians*. The female singer to the left, viewed from the back reading a score, is a direct quotation from the singer in Caravaggio's picture, proving that both the arresting style and the Bacchic theme of this painting depend on the work Del Monte

commissioned. In the second painting Paolini took the opposite course, suppressing rather than amplifying the classical-allegorical content and evoking an ordinary musical performance. Three women, wearing unmistakably seventeenth-century costumes, substitute for the dressed-up youths in Caravaggio's picture, and Cupid is given an active rather than a passive, purely emblematic role. The pink he offers would seem to indicate that these female musicians at once inspire love through their music and are its object. A similar, albeit homoerotic significance occasionally has been attached to the androgynous youths in Caravaggio's picture, but the purposive changes Paolini introduced in his composition belie such an interpretation. At the same time, Paolini's two pictures—with their clear dependence on *The Musicians* for a number of compositional details—underscore the weak point of Caravaggio's approach to allegory at this time, for by simply eliminating the wings of Cupid, what had been an allegory of Music could be transformed into a quirky but nonetheless acceptable genre painting. Sometime in the late seventeenth or early eighteenth century this change was, in fact, made in Caravaggio's picture. The wings were scraped and then painted out (the overpaints were removed in 1983).

The compositional and thematic awkwardnesses in this picture stem in large part from Caravaggio's habit of painting from posed models. The spatial relationships—or rather the lack of them—between the figures demonstrate that the composition is the result of Caravaggio's having painted each figure separately, relating part to part in an elaborate collage. Similarly, an examination of the drapery reveals that the lute player was initially depicted wearing a simple shirt and sash that were then revised in an attempt to give them a more allusive and timeless quality.[38] What Del Monte made of this peculiar marriage of allegory to a Giorgionesque style is uncertain. He did, however, own two "Venetian" music pieces, both of which are listed in the 1627 inventory of his collection. One was purchased in 1628 by Francesco Barberini, who made a gift of it to Queen Henrietta Maria of England in 1635; it survives at Hampton Court (fig. 12).[39] The picture is possibly a copy after an early work by Dosso Dossi, but in the seventeenth century it was not unreasonably given a tentative attribution to Giorgione; it belongs to a quintessentially Venetian genre of procuress scenes in which a man—in this case a soldier—makes advances to a woman with a musical instrument, here an emblem less of love than of lasciviousness. The second painting may also have belonged to this type, for in the sale of Del Monte's collection it appears as the work of the Venetian artist Bernardino Licinio, who painted several such pictures.[40] This picture was sold in 1628 together with Caravaggio's *Musicians*. Although Licinio is not usually considered one of Caravaggio's precursors, the remarkably placid naturalism of his figures, invariably shown against plain, darkly colored backgrounds, is far from unrelated to Caravaggio's early work, and there is a real possibility that in commissioning *The Musicians* and later *The Lute Player*, Del Monte had the Giorgionesque style and hauntingly poetic quality of these two "Venetian" pictures in mind. In his palace on the Ripetta, *The Musicians* hung in a small room with Jacopo de'Barbari's monumental map of Venice—a poignant reminder of his birthplace and cultural background.[41]

Fig. 12. Dosso Dossi (or copy after), *A Soldier and a Girl Holding a Flute*.
Her Majesty Queen Elizabeth II.

Del Monte's interest in concert scenes was by no means exhausted by Caravaggio's *Musicians*. The 1627 inventory lists no fewer than four other pictures with musical themes, including two of concerts. There was a picture of Orpheus by Bassano, a scene of Parnassus by Antiveduto Grammatica, Caravaggio's onetime associate, and concert scenes by Gerrit van Honthorst and Grammatica. The Honthorst is lost, but it was, like the Hampton Court "musica," purchased by Francesco Barberini, in whose inventories it is described as a candle-lit scene showing a woman playing a "Spanish" guitar and two men singing and playing on lutes.[42] Grammatica's composition has been plausibly identified in a copy depicting a woman playing a harpsichord accompanied by a youth playing the transverse flute and a man playing a theorbo (fig. 13).[43] The open part-book with its upturned page is an obvious derivation from Caravaggio's picture, but unlike that work, both Honthorst's and Grammatica's concert scenes would appear to be straightforward portrayals of musical performances with no allegorical intent. Not only are the figures dressed in contemporary costume, but the inclusion of a guitar in each (in Grammatica's picture a guitar lies on the table) and of a theorbo in one is in conformity with musical taste after the turn of the

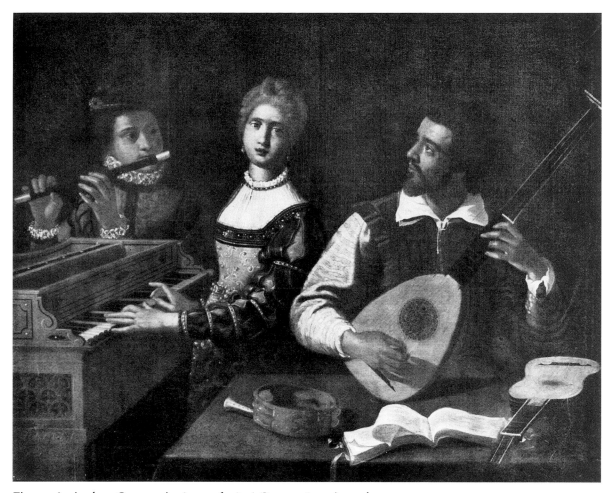

Fig. 13. Antiveduto Grammatica (copy after), *A Concert*. Location unknown.

century. In his discourse on music written about 1628, only a few years after these pictures were painted, Giustiniani reports that it was the fashion to sing "with one or at most three voices accompanied by suitable instruments such as the theorbo, guitar, harpsichord, or organ. . . . In the past the lute was also much in use, but this instrument is almost completely abandoned since the theorbo has been introduced . . . and at the same time the Spanish guitar has been introduced throughout Italy, and especially in Naples, and it would seem that it and the theorbo have conspired to totally banish the lute."[44] Caravaggio's *Musicians*, with the soloist accompanied by lute and cornetto, exemplifies an earlier fashion.

The taste for the solo voice accompanied by an instrument went back to the early sixteenth century and persisted throughout the heyday of polyphonic madrigals and songs. Indeed, it was common for madrigals composed for several voices to be arranged for solo performance. In 1536 Adrian Willaert, the Flemish composer and choirmaster at Saint Mark's in Venice, published a selection of madrigals by Philippe Verdelot arranged for solo voice accompanied by the lute.[45] The most famous statement for the superiority of solo singing appears in *The Book of the Courtier* (1528), where Castiglione has his friend, the

diplomat Federico Fregoso, declare that "truly beautiful music consists . . . in fine singing, in reading accurately from the score and in an attractive personal style, and still more in singing to the accompaniment of the viola. I say this because the solo voice contains all the purity of music, and style and melody are studied and appreciated more carefully when one's ears are not distracted by more than one voice, . . . something which does not happen when a group is singing, because then one singer covers up for the other."[46] Castiglione was referring not to the performance of madrigals and songs by professional singers but to their realization by amateurs, since a mastery of music was essential to his ideal courtier.

Del Monte grew up at the court of Urbino, where he was inculcated with Castiglione's vision. He, in fact, professed to sing to the "Spanish" guitar, which shows how well he kept abreast of changes in musical taste.[47] Life at the Della Rovere court in Urbino and Pesaro during these years is wonderfully evoked in an account of a boat outing undertaken by Del Monte's brother, the mathematician Guidubaldo del Monte, and the political writer and moralist Fabio Albergati, one of the teachers of the future duke, Francesco Maria della Rovere. Encountering another boat, Guidubaldo proposed for their diversion that "they all sing some motets by Willaert."[48]

Looking back at his own youth, Giustiniani recalled that his father had sent him to a school of music, noting that by about 1628, when he wrote his discourse, all this had changed: music was no longer played by gentlemen, "nor is singing with several voices from a part-book practiced any longer, as it was in the past."[49] He attributed this change to the new perfection demanded in music and the increasing dependence on professional singers, which in turn further contributed to the appreciation of the solo performance.[50] Caravaggio's *Musicians* reflects this taste for the accompanied solo voice performance. Unfortunately the music in the part-books is no longer legible, and it is not possible to say with certainty what the youth on the right is preparing to perform, although it was probably a madrigal from the circle of the Flemish composer Jacques Arcadelt, to judge from two paintings of lute players that Caravaggio carried out for Del Monte and Giustiniani in the subsequent two or three years.

Ever since its purchase in Paris for Czar Alexander I in 1808, *The Lute Player* (Hermitage Museum, Leningrad; figs. 14–16) has deservedly been regarded as one of Caravaggio's most beautiful and poetic works. However, in the seventeenth century this privileged position was contested, if not eclipsed, by a related composition owned first by Cardinal del Monte and then, after 1628, by the Barberini (figs. 19–21). It is this latter picture—reidentified and newly cleaned—that is the focus of this exhibition and essay.

A few years ago it would not have been seriously entertained that Caravaggio painted related compositions of a lute player for each of his two major patrons in Rome.[51] But with the recent publication of a variety of inventory notices and other documents, the existence of two autograph pictures of this subject can be established unequivocally. According to both Baglione and Bellori, Caravaggio painted a picture of a lute player for Del Monte during his residence in Palazzo Madama. Baglione mentions the picture immediately after

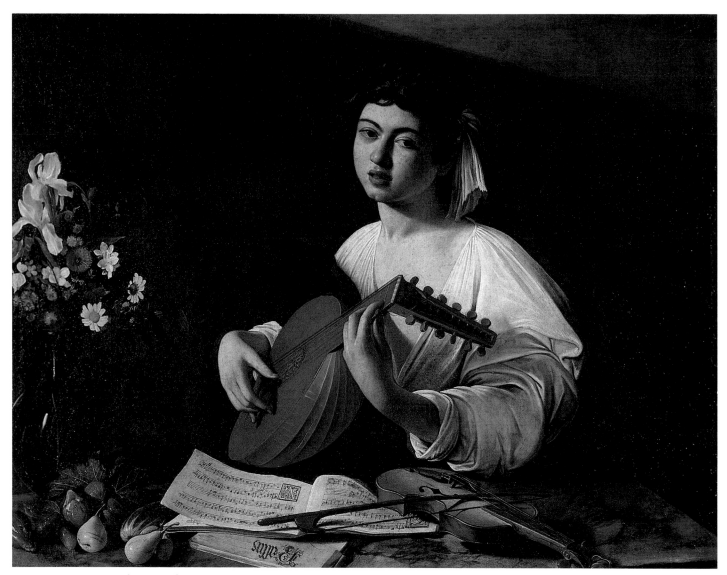

Fig. 14. Caravaggio, *The Lute Player*. State Hermitage Museum, Leningrad.

Overleaf:

Figs. 15 and 16. Details of fig. 14.

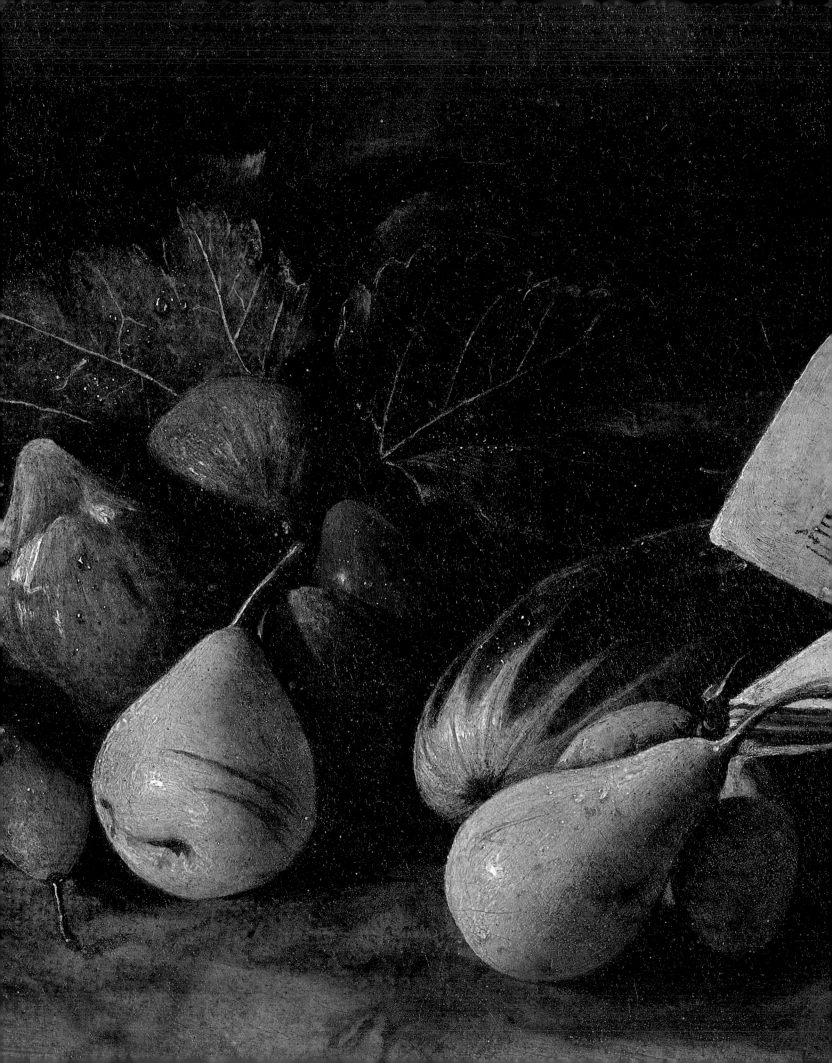

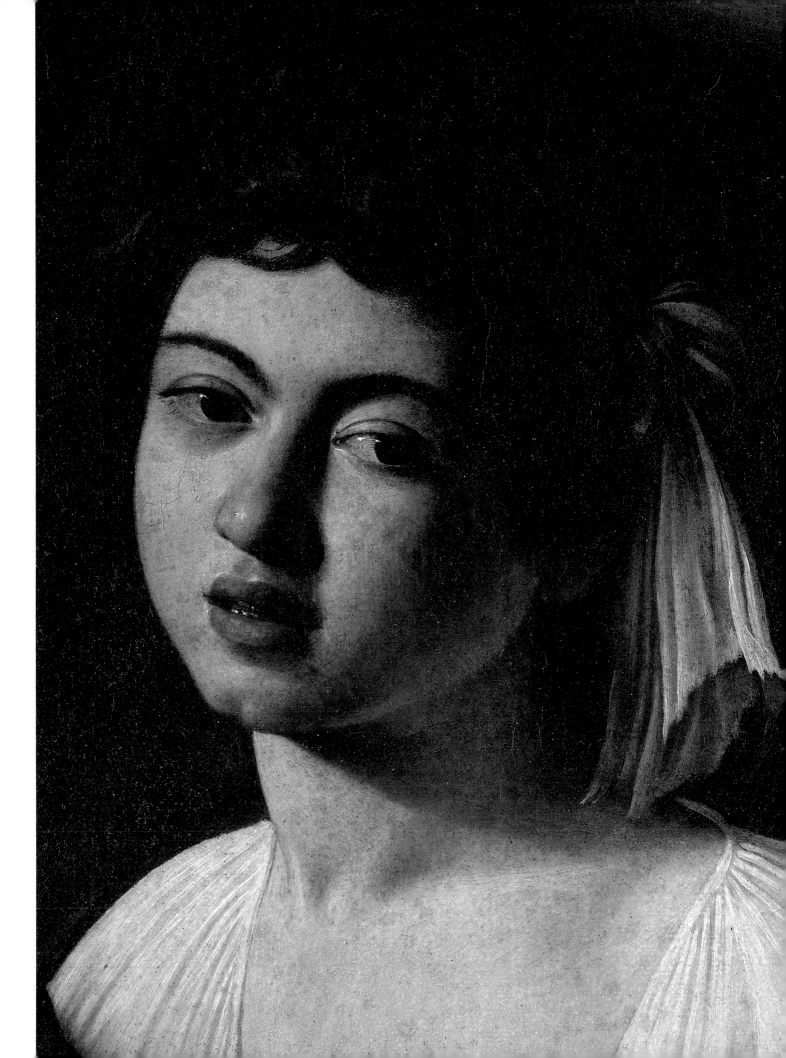

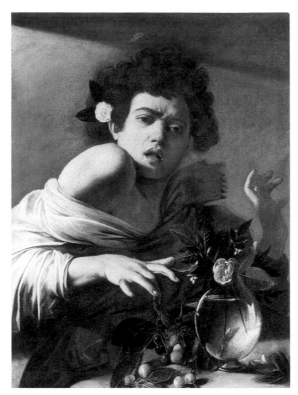

Fig. 17. Caravaggio, *Boy Bitten by a Lizard*. National Gallery, London.

The Musicians;[52] Bellori, who mistook the sitter for a woman, saw it in Cardinal Antonio Barberini's palace.[53] In fact, the 1627 inventory of Del Monte's collection lists "a man who plays a lute, by Michelangelo da Caravaggio," and this painting was sold the following year to Cardinal Barberini, whose purchase of "a young music player by Caravaggio" is recorded in his accounts. The picture can then be traced continuously in Barberini inventories until 1948, when it was bought by the father of its current owner (see cat. 5). The *F.13.* in the lower right corner is the number assigned to the picture in the 1817 Barberini *fidecommesso* (entailment). What can only be the version of the composition now at Leningrad (fig. 14) appears in the 1638 inventory of Giustiniani's collection, where it is described as "a half-length figure of a youth who plays the lute, with diverse flowers and fruits and music books... from the hand of Michelangelo da Caravaggio."[54] Remarkably enough, given the detailed execution, it hung above a door in the same large gallery that contained twelve other works by Caravaggio, including the first version of his altarpiece of Saint Matthew painted for San Luigi dei Francesi and the *Love Triumphant* (*Amor vincit omnia*), now in the Staatliche Museen, Berlin—the most famous picture in Giustiniani's collection and one of the most highly prized paintings in seventeenth-century Rome (Giustiniani is reported to have been offered an astonishing two thousand doubloons for it in the mid-1630s).[55] *The Lute Player*'s high placement and proximity to such celebrated works by the artist may account for its omission by early biographers, although in 1673 it was the subject of a long epigram by Giovanni Michele Silos. It was purchased from the Giustiniani by Baron Dominique Vivant-Denon, who in turn sold it to the czar.

The persistent confusion of these two related but quite distinct pictures can be attributed, first, to an ellipsis in Baglione's biography of Caravaggio and, second, to a modern prejudice that great artists do not repeat themselves. In Baglione's account of the works Caravaggio carried out for Del Monte, he noted a painting of "a youth playing a lute, the whole seeming most lifelike and true, with a carafe of flowers filled with water, in which was excellently depicted the reflection of a window and other objects in the room, and on those flowers are dewdrops imitated with exquisite diligence. And this work [Caravaggio] said was the most beautiful he had ever made."[56] This passage has traditionally been associated

with the painting in Leningrad, which indeed includes, among other things, a carafe of flowers. However, quite apart from the problems of ownership raised by this identification, neither the reflections in the water nor the dewdrops admired by Baglione appear in that work, though they are a conspicuous feature of a still life in Caravaggio's *Boy Bitten by a Lizard* (National Gallery, London; fig. 17). The most cogent explanation for these discrepancies is that in this passage Baglione had intended to describe not one but two pictures: the "lifelike and true" *Lute Player* and an independent still life of a carafe of flowers; both were listed in Del Monte's 1627 inventory, and both were subsequently described by Bellori.[57] Interestingly, the disparity between Giustiniani's picture and Baglione's account seems to have been noticed by an early copyist, who substituted for the carafe of flowers in the Leningrad painting one that not only matches the description in Baglione but may actually record the lost still life owned by Del Monte, producing a sort of "corrected" copy (fig. 18). It is perhaps worth pointing out that Baglione's report that Caravaggio considered a still life

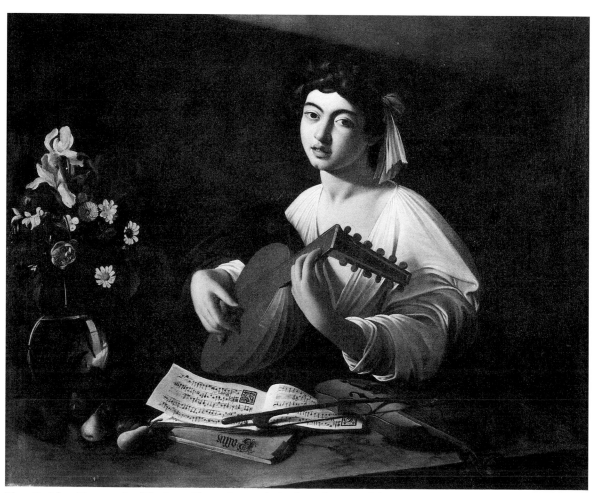

Fig. 18. After Caravaggio, *The Lute Player*. Formerly in the collection of the Duke of Beaufort, Badminton.

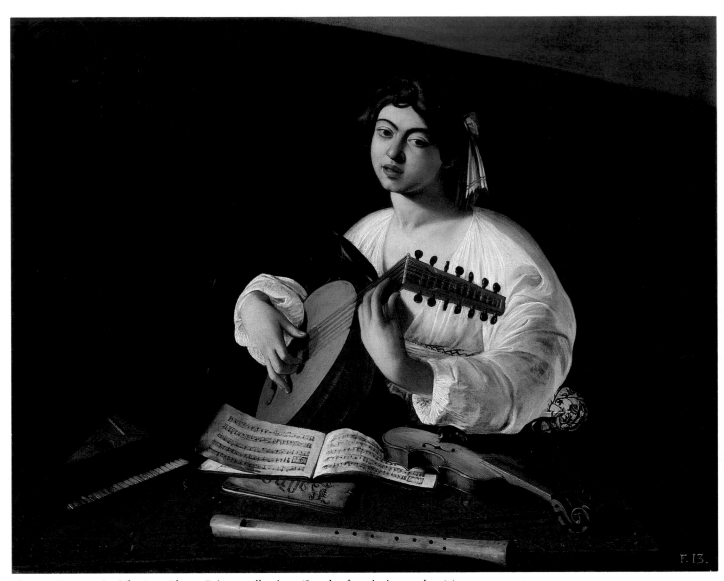

Fig. 19. Caravaggio, *The Lute Player*. Private collection. (See also frontispiece and p. 8.)

Fig. 20. Detail of fig. 19.

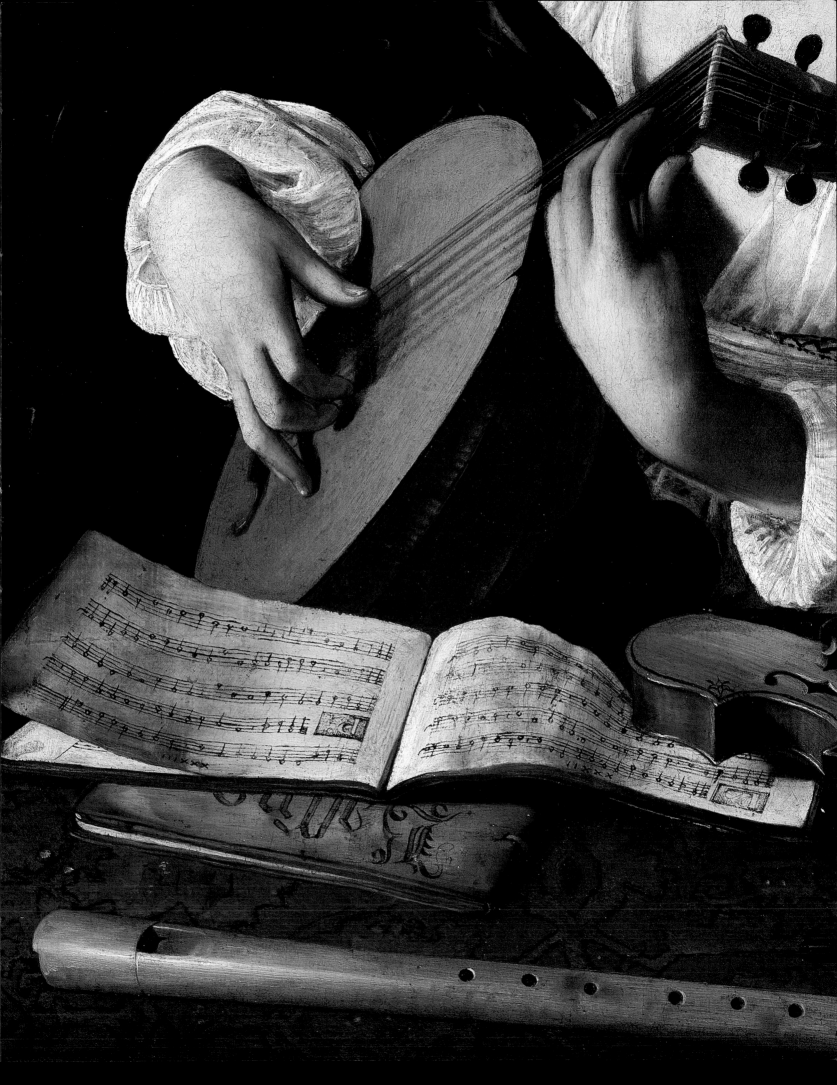

Fig. 21. Detail of fig. 19.

of a vase of flowers his finest work fits in per- fectly with a comment recorded by Giustiniani to the effect that Caravaggio thought it as difficult to make a good painting of flowers as one of figures: a view that his contemporaries would have regarded as a direct assault on pre- vailing critical values.[58]

Although the earliest record of the two Lute Players postdates their execution by more than three decades, the sequence and to some extent the circumstances of their commissions may be reconstructed with a high degree of probability. X rays of the Del Monte version reveal that in its initial stages of execution it was far closer in design to the Giustiniani pic- ture and replicated a number of features found in that work (fig. 22). Most readily apparent is the inclusion of the still life of fruit to the left of the open part-book, with the pears, cucumber, figs, and vine leaves arranged in much the same positions (the pear stem that overlaps the part-book in the Giustiniani picture is visible as a pentimento in the Del Monte painting; fig. 23). In both pictures the part-books and violins are also positioned identically. Moreover, the lute player in the Del Monte painting originally had the narrow shoulders of his counterpart in Leningrad, and he held his lute in the same position, with the pegbox angled downward more decisively. Indeed, when a tracing of the Giustiniani-Leningrad picture is imposed over an X ray of the Del Monte painting, the inescapable conclusion is that a mechanical tracing of the former was used as an aid in producing the latter (fig. 24). This was a far from uncommon practice: it is referred to in the early fifteenth century by the artist Cennino Cennini and seems to have been employed extensively by the Bassano in the sixteenth.[59] Even the placement of the bow in the Del Monte painting seems to have been determined by the design of the other picture, since the bow hairs intersect the violin pegbox at precisely the same point as the edge of the marble slab in that work. There can therefore be no doubt that the Giustiniani-Leningrad *Lute Player* was painted first and that the second version repeated some of its basic features but with significant alterations to the composition.

From the outset the Del Monte picture was larger. Apart from the small spinet, or spinettina, it included an additional instrument in the foreground—the marvelously ren- dered tenor recorder—and the lute player was shown seated behind a table covered with a contemporary oriental carpet instead of a marble slab. Moreover, the table is shown with its front edge parallel rather than at an angle to the picture plane, thereby accentuating the impression of space. These differences underscore the fundamental independence of the

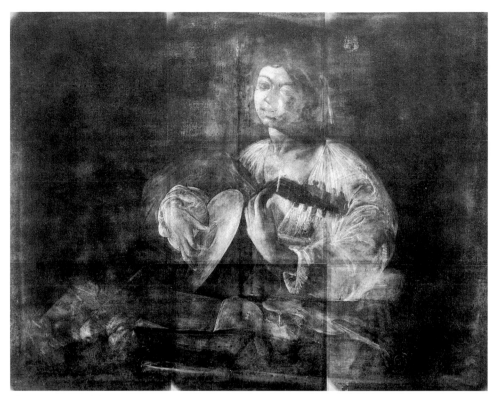

Fig. 22. X ray of fig. 19.

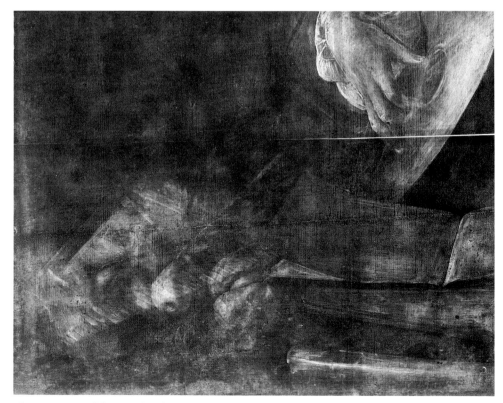

Fig. 23. X ray of fig. 19 (detail showing still life of fruit beneath spinettina).

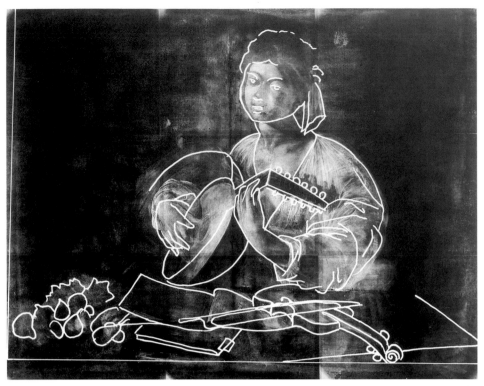

Fig. 24. Tracing of contours of fig. 14 (Giustiniani *Lute Player*) superimposed over X ray of fig. 19 (Del Monte *Lute Player*).

two pictures and the degree to which the one served only as a point of departure for the other. There is, for example, no evidence that a carafe of flowers was ever contemplated in the Del Monte version, probably because he already had a picture of this subject; moreover it would have left little room for the birdcage with a finch, and there is no sign of it in the X rays. The still life of fruits on the left was apparently abandoned early on in favor of the spinettina, which complements the other instruments and enhances the spatial geometry of the still life. But the most notable change is in the style of the two pictures: the exquisitely wrought details and diaphanous light that confer a languorous sensual beauty on the Giustiniani picture have become, in the Del Monte version, a less meticulous, even—in the shirt—almost impressionistic brushwork with stepped-up contrasts that produce a more direct, palpable image. Indeed, aside from their shared compositional elements, the two pictures could hardly be less similar in their effect. Nor did the distinctive traits of the Del Monte *Lute Player* escape the critical acumen of Bellori, who studied it together with Caravaggio's *Cardsharps* and *Saint Catherine of Alexandria* (fig. 25) in Cardinal Antonio Barberini's palace. In *The Cardsharps* he saw a clear reflection of "that straightforward style of Giorgione, with tempered darks," but in *Saint Catherine* and *The Lute Player* he noted "a stronger color, Caravaggio having already begun to strengthen the darks."[60] Whereas Giustiniani's picture must have been painted not long after *The Musicians* and makes a conscious reference to the Venetian style of Del Monte's two early music pieces, the second

picture was painted perhaps a year or two later and marks a significant step toward the more dramatically lit, highly focused style of Caravaggio's maturity.

X rays reveal one further circumstance of interest: in painting the second lute player, Caravaggio used a canvas on which a religious subject, intended to be viewed vertically, had been painted (figs. 26–28). Much of the paint of this composition was scraped away before the new picture was begun, but beneath the face of the lute player and the violin and partbook are clearly visible the heads of two male figures, one with a mustache and short beard, the other with close-cropped hair. To judge from the figure on the left, whose hand is raised devoutly to his chest and who raises his eyes toward what is now a void, the picture showed two half-length donor figures with, above, a divine apparition, conceivably of the Virgin and Child. It is a type of devotional picture

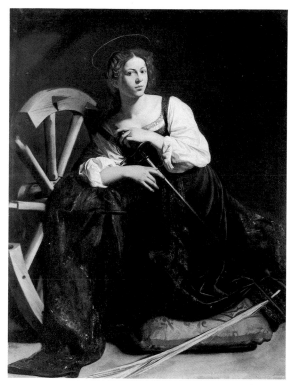

Fig. 25. Caravaggio, *Saint Catherine of Alexandria.* Thyssen Collection, Lugano.

that was especially common in north Italy—the work of Giovan Battista Moroni in Bergamo comes to mind—and that Caravaggio must have been familiar with. This is not the only case in which Caravaggio painted a secular subject over an abandoned religious picture. Beneath *The Fortune Teller* is a figure of the Virgin Mary that is reminiscent of the work of the Cavalier d'Arpino, to whom it is indeed frequently ascribed.[61] There is, however, no compelling reason why both this figure and the devotional composition beneath the Del Monte *Lute Player* could not have been painted by Caravaggio himself, possibly in Arpino's workshop. Caravaggio is known to have painted copies of devotional pictures during his first years in Rome, and he must also have produced a number of religious pictures for prospective clients. Some of these unfinished or unsold pictures could have been painted over to produce other, more salable paintings or to respond to specific commissions. Undoubtedly, among the studio materials Caravaggio brought with him to Palazzo Madama were canvases such as these, which he then reused (this was a far from uncommon practice).

Not only does the technical information furnished by the X rays of the Del Monte *Lute Player* throw light on an aspect of Caravaggio's early years in Rome and his methods of working, but it also bears directly on the interpretation we attach to this and the earlier version of the picture owned by Giustiniani, for to some extent the changes introduced in the one must represent a conscious criticism or clarification of the ideas underlying the other. The substitution of the spinettina for the fruit and the decision to include

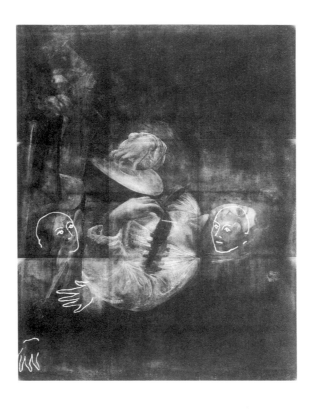

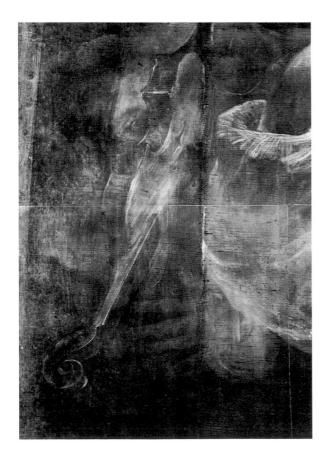

Figs. 26–28. X rays of fig. 19: two male heads outlined (top) and details of these heads (bottom).

a birdcage with a finch rather than a carafe of flowers speak quite eloquently on this point, for whereas the function of the extraordinarily beautiful still life in the Giustiniani picture may initially seem somewhat ambiguous (does it point up an allegorical meaning, or is it primarily a pictorial embellishment?[62]), the bird and additional instruments in the Del Monte painting find a ready explanation in Ripa's *Iconologia*.[63] Ripa recommends that Music be personified as a "woman, who with both hands holds Apollo's lyre, and at her feet are various musical instruments." He further notes that "the nightingale was a symbol of Music for the varied, suave, and pleasing melody of its voice, since the ancients perceived in the song of this bird the perfect science of music, that is a voice now low, now high, and everything needful to please." Caravaggio shows a young man playing a lute, not a woman with a lyre; the musician is seated with instruments before him on a table, not at his feet; and the caged bird is a finch, not a nightingale (al-

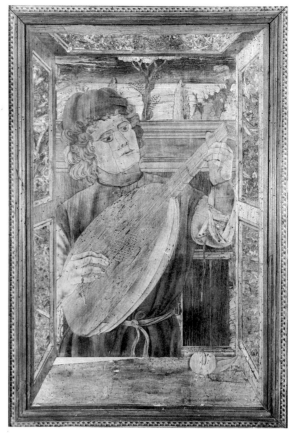

Fig. 29. Antonio Barili, *A Lute Player* (detail from choir stall). Collegiata, San Quirico d'Orcia.

though both were popular songbirds in the seventeenth century; the Barberini fed their nightingales grated pasta[64]). However, Ripa's text was used by artists as a source for possible motifs rather than a canonical formula. Laurent de la Hire's *Allegory of Music*, for example, which was part of a series carried out in 1649–50 illustrating the liberal arts, reveals a similar license (see cat. 19). There the musician is shown seated, playing an angelica, while on the table before her are an assortment of musical instruments and an open score. Interestingly enough, La Hire knew Caravaggio's *Musicians* firsthand, since he inventoried it in the collection of Cardinal Richelieu,[65] but he did not know the Del Monte *Lute Player*. The similarities of presentation between his picture and Caravaggio's derive less from a dependence on Ripa's text than from a well-established convention for portraying solo musicians.

This convention goes back at least to the fifteenth century, and it governs even the marvelous depiction of a lutenist in the intarsia choir stalls commissioned in 1483 from Antonio Barili for the chapel of San Giovanni in the cathedral of Siena (the stalls are now in the Collegiata at San Quirico d'Orcia; fig. 29). The figure—conceivably a portrait—is shown behind a casement on which a peach rests. Bartolomeo Passerotti's 1576 portrait of a musician (Museum of Fine Arts, Boston; cat. 11) and Annibale Carracci's depiction of his friend

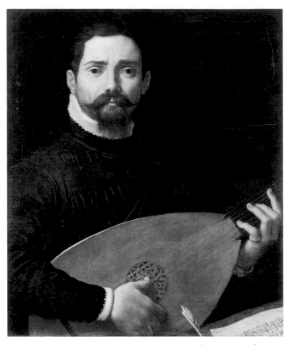

Fig. 30. Annibale Carracci, *The Lute Player Mascheroni.* Staatliche Kunstsammlungen, Dresden.

the musician Mascheroni (fig. 30)[66] vary this formula but little. In Passerotti's picture a folded sheet of paper with an inscription on one side and musical notations on the other lies on a table behind the sitter, while in Annibale's portrait Mascheroni sits behind a table set at an angle to the picture plane with an open score and a pen before him. This formula could also be adapted to a purely allegorical depiction of a courtesan whose music is the agent of seduction. Bartolomeo Veneto made a specialty of this type, repeating an obviously popular composition of a coy, modestly attired maiden who charms with the notes of her lute while a part-book turned toward the viewer invites his participation in an amorous duet (fig. 31). Curiously, in the versions of this composition in Boston and Milan the figure has been supplied with a halo in an attempt to transform the courtesan into Saint Cecilia.[67] An even more elaborate picture could result if the sitter were a gentleman rather than a musician and the instrument a symbol of his cultural achievement rather than his profession. In a charmingly stylized portrait by the Florentine friend of Andrea del Sarto, Bachiacca, a dreamy-eyed youth holding a lute sits on a ledge with, to either side, a vase of flowers and an hourglass (fig. 32). These are symbols of the transience of love, further alluded to by the appearance in the background of Apollo kneeling before Daphne transformed into a tree and of Delilah cutting Samson's hair before a triumphal chariot bearing Cupid: stories of love denied and love betrayed.[68] The pictures by Bartolomeo Veneto and Bachiacca serve as a reminder that madrigals invariably have an amorous content and that music itself could be a symbol of transient pleasures.

This tradition of depicting solo musicians, coupled with Caravaggio's habit of painting directly from posed models, determined the character of the two Lute Players, just as the north Italian concert scenes shaped *The Musicians*. In both pictures a seated youth wearing a loose blouse gazes at the viewer, his hand striking a chord, his lips parted in song. An open part-book, which is turned away from the viewer and toward the singer, lies on the table before him. Despite their conventional title, the pictures show not a lute concert but an accompanied solo voice performance. Indeed, the position of the tongue against the teeth conforms to the instructions on enunciation given by Giovanni Camillo Maffei in his 1562 letter on singing.[69] In the Giustiniani version (fig. 14) portions of four madrigals by Jacques Arcadelt can be identified: "Chi potrà dir quanta dolcezza prova," "Se la dura durezza in la mia donna dura," "Voi sapete ch'io v'amo," and "Vostra fui e sarò mentre ch'io viva" (for

the texts of these, see appendix). Arcadelt was among the composers Giustiniani cites as most in vogue during his youth, and it is therefore not surprising that the two madrigals in the Del Monte picture are also taken from the *Primo libro*, Arcadelt's popular compilation of madrigals (fig. 20). They are, however, not by Arcadelt but by his contemporaries the Florentine Francesco de Layolle and the Fleming Jacques de Berchem, a protégé of Willaert: "Lassare il velo" and "Perchè non date voi, donna crudele."[70] All these madrigals are declarations of love and undying devotion, and the sensuality of the pictures must have been conceived to complement the musical content.

Caravaggio may actually have used a specific edition of Arcadelt's *Primo libro*, for the distinctive decoration of the "L" and "P" is similar to that favored by the Venetian publisher Antonio Gardane (fig. 33). By contrast, the letters in the Giustiniani picture are characteristic of the Roman publisher Valerio Dorico.[71] Del Monte had a large collection of printed music, as did Giustiniani, and there can be little doubt that Caravaggio was provided with the bass (*bassus*) part-books that would have been used for the lute accompaniment of a real performance and that he was told which madrigals to show: his omission of the texts in all but one instance attests to a highly personalized program.

The flowers in the Giustiniani picture comment on the theme expressed by the madrigals in the same way that the still-life elements in Bachiacca's portrait of a lovesick youth affirm that love is transient.[72] The fruits function in a similar fashion: a still life of peaches

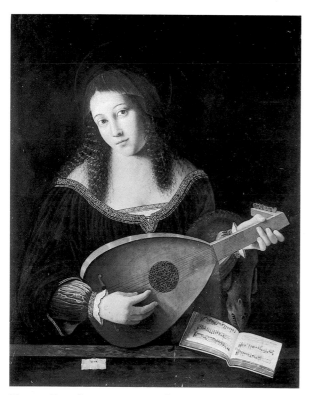

Fig. 31. Bartolomeo Veneto, *The Lute Player*. Isabella Stewart Gardner Museum, Boston.

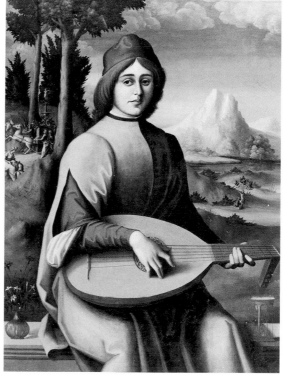

Fig. 32. Bachiacca (Francesco d'Ubertino), *A Youth Playing a Lute*. New Orleans Museum of Art.

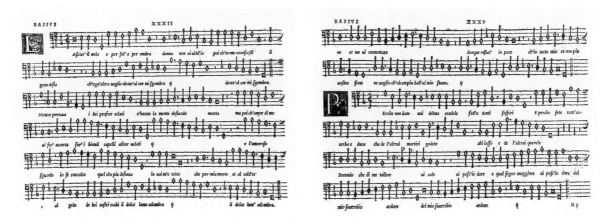

Fig. 33. Pages from Jacques Arcadelt, *Primo libro di madrigali* (Antonio Gardane, Venice). Special Collections Department, University of Utah Libraries.

(the fruit that appears in Barili's intarsia) by Ambrogio Figino, Caravaggio's older compatriot in Milan, bears on its reverse an inscription alluding to the perishability of fruit,[73] while the great Lombard still-life painter Evaristo Baschenis was later to include an occasional piece of overripe fruit as an additional vanitas element in his compositions of musical instruments (cat. 17). In Caravaggio's picture the figs have burst their skins, and the small pear is blemished. The split in the ribbed body of the lute is probably no less intentional: the instrument—a six double-course lute, perhaps already somewhat old-fashioned in the 1590s—is past its prime, and its amatory notes would have lost their earlier resonance. In the Del Monte *Lute Player* music is not simply the vehicle of the poetic conceit—the picture must have been conceived as an allegory of Music. Only the discolored pages of the worn part-book recall the vanitas theme that is so conspicuous in the Giustiniani picture.

The instruments—the lutes, violins, tenor recorder, and spinettina—were probably chosen with as much care as was the music. It is noteworthy that the same seven double-course lute appears in the Del Monte *Lute Player* and *The Musicians*, together with a closely similar violin. Del Monte's collection of musical instruments was extensive, containing a number of exceptional pieces. One of these, a large harpsichord with two registers made by Giovanni Battista Bertaccino, was purchased by Antonio Barberini and put into working order for the musical events he sponsored.[74] In addition to the various lutes, guitars, organs, and harpsichords listed in Del Monte's 1627 inventory, there is described what must have been a cross between a luxurious toy and a miniature instrument, a small octave spinet that was kept in a red leather case lined with blue silk ("Un'cembalino all'ottava anche con cassa, Corame rosso foderato di taffetta pavonazzo")—possibly the spinettina Caravaggio substituted for the still life of fruit.[75] Such an instrument was not suitable for playing before a large audience, and its inclusion underscores the intimate nature of the singer's performance.

The highly specific character of the Del Monte *Lute Player*, with its array of instruments and part-books, strongly argues that, like *The Musicians*, it was conceived neither

44

exclusively as an allegory nor simply as a plausible representation of a musical performance but was intended to evoke the private concerts Del Monte held in Palazzo Madama. Del Monte was at the center of musical life in Rome. His friend and political ally Cardinal Alessandro Montalto was one of the most important patrons of music in the city, while his close ties with the Florentine court of Ferdinando de'Medici, which both he and, to a degree, Montalto served, placed him in touch with some of the most significant musical innovations of the day.[76] He was, for example, in Florence with Montalto for the productions of Emilio de'Cavalieri's *Gioco della cieca* in 1595 and of Jacopo Peri's *Dafne* in 1599, both early experiments in antique-inspired musical dramas and recitative. In 1595 Del Monte relayed Montalto's request to Ferdinando de'Medici for the loan of Onofrio Gualfreducci, the outstanding male soprano who had starred in Cavalieri's elaborate and spectacularly successful celebrations for the marriage of Ferdinando and Christine of Lorraine in 1588. In Rome, Del Monte, Montalto, and Cardinal Pietro Aldobrandini, the powerful nephew of Pope Clement VIII, formed a close-knit circle united by their politics (they opposed an alliance of the papacy with Spain) and their love of music.

There were few musical performances of note that Del Monte did not attend. On June 24, 1595, Del Monte reported that he, Aldobrandini, and a few others were at a banquet hosted by Montalto "at which the usual music was performed," and the following month the same cardinals were his guests at a similar event. This was the normal rhythm. Some of these gatherings were elaborate, combining hunting, theatrical displays, and the staging of pastorals or comedies with musical interludes (*intermedi*), but others must have been quite informal. In his discourse Giustiniani, who was a friend and business associate of Montalto's, alludes to the private concerts held in a small chamber of his palace, at which a professional musician might perform for guests on the theorbo, spinet, or cornetto. However, the event that has—quite unjustifiably—received the most publicity among modern writers on Del Monte was a banquet given in 1605 by Montalto for Aldobrandini, Del Monte, "and the other gentlemen, as is usual, there having been very beautiful festivities for recreation after dinner, with dances with the outstanding masters, and since there were no women, many youths took part, dressed as women, which provided not a little entertainment."[77] This event has frequently been interpreted as a dissolute homosexual party,[78] but this hardly accords with Montalto's reputation in Rome. It was probably a fairly typical and far from overly lavish ecclesiastical gathering at which women were excluded as a matter of course.[79] Some idea of the nature of these evenings (though one of mixed company) can be gathered from an engraving designed by Andrea Sacchi showing a ballet of nymphs and shepherds held in honor of Prince Alexander of Poland in Casa Falconieri in 1634 (fig. 34).[80] The two singers and the musicians, who play a harpsichord, viola da gamba, and theorbo—are grouped at the left, while the guests have cleared a space in the center for the dancers, who are attired in blouses, loose-fitting tunics, and sandals and wear wreaths on their heads. The importance of these evening amusements should not be minimized, for apart from the social visibility they assured their sponsors, they could be as effective as the gift of a highly

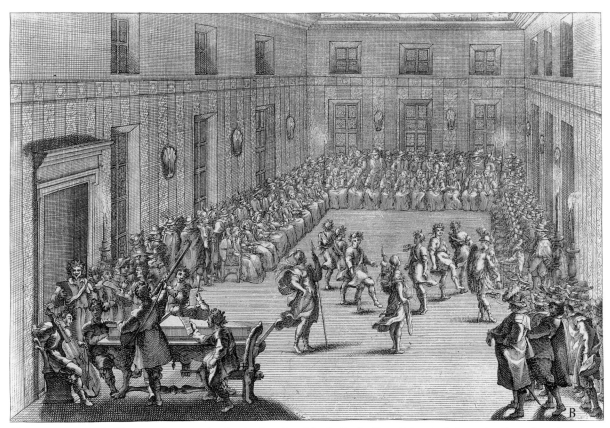

Fig. 34. François Collignon (after a design by Andrea Sacchi), *Ballet in Casa Falconieri,* from the *Festa fatta in Roma alli 25 di febraio, MDCXXXIV.* The Metropolitan Museum of Art.

prized work of art in the advancement of a political cause. Indeed, Del Monte, who was adept at this sort of lobbying, advised Ferdinando de'Medici that to impress Pietro Aldobrandini, the presentation of a new coach or the performance of Peri's *Dafne*, premiered the preceding year, would be advisable.[81]

In 1600 Del Monte wrote to Bellisario Vinta in Florence that a number of cardinals, among them Montalto and himself, supported singers in the papal choir. Montalto's protégé was the Neapolitan Melchior Palentrotti, while Del Monte provided for Pedro Montoya, a Spanish male soprano, or castrato, who had entered the Sistine Choir in 1592. Montoya appears to have been a lazy but promising singer, for in 1597 Emilio de'Cavalieri reported that he had given lessons to "Montoya . . . who lives with Del Monte . . . and the Cardinal . . . was amazed because he can sing on a level with Onofrio [Gualfreducci], and if he doesn't create problems, within a month he will surpass Onofrio."[82] As was the case four decades later, with Antonio Barberini's favored singer-in-residence, the castrato Marc'Antonio Pasqualini, Montoya must have performed at some of the private musical events sponsored by Del Monte, and it may be that the sitter for the two Lute Players was Montoya or another professional singer dressed for one of these evening musicales.[83] This would explain some of the features that have most troubled modern viewers and that led Bellori to mistake

the gender of the singer in Del Monte's picture: the fleshy features of the face (evidently characteristic of castrati), the seemingly penciled eyebrows, the wiglike hair (or is it simply a wig?) tied with a hair band, and the blouse gathered, in Del Monte's picture, just below the waist with a patterned sash. Interestingly, the same type of blouse is worn by one of the figures in Bartolomeo Cavarozzi's Caravaggesque *Lament of Aminta* (cat. 12), a picture that takes as its inspiration the musical setting by Erasmo Marotta of Torquato Tasso's immensely popular pastoral poem.[84] Marotta's madrigals were sometimes sung as *intermedi* between the acts of plays or recitations, and the picture was possibly directly inspired by a particularly memorable performance, since four versions of the composition are known. It is not without interest that Andrea Sacchi's allegorical portrait of Marc'Antonio Pasqualini crowned by Apollo (cat. 18), painted about 1640, shows the singer clad in a similar loose-fitting shift adorned with a panther's pelt that perhaps alludes both to his musical victory and to one of his major roles.

Caravaggio's singers do not impersonate a specific character, but their dress seems nonetheless to conform to conventions for pastoral or classical subjects, as would be appropriate for pictures with an allegorical intent. This point can be demonstrated by comparing the costume of Caravaggio's singers with that of Hendrik Terbrugghen's female lute player (Kunsthistorisches Museum, Vienna; fig. 35). She wears a turban, an earring, and a patterned dress remarkably like the garb of the female singer in Theodoor Rombouts's depiction of two professional musicians performing on an improvised stage in Rome, probably between the acts of a comedy or at a fair (fig. 36).[85] This comparison underscores the

Fig. 35. Hendrik Terbrugghen, *The Lute Player.* Kunsthistorisches Museum, Vienna.

close relationship that continued to exist between theater and art—one that had proved particularly fruitful for Caravaggio in *The Cardsharps* and *The Fortune Teller*.

Although the identification of the singer in the two Lute Players as Pedro Montoya is no more than a conjecture, it has the advantage of relating the pictures to contemporary musical practice and to the tastes of Caravaggio's patrons. It also conforms to Caravaggio's practice of exploiting the world around him to give new life to timeworn subjects. After 1595 his world was no longer confined to street life but included the refined surroundings of his new aristocratic patrons. Far more than even *The Musicians*, the two versions of *The Lute Player* evoke this sophisticated environment.

Caravaggio's art has always been subject to a wide range of interpretations. To established Roman artists as well as to classically minded critics like Agucchi and Bellori, his aggressive naturalism and reliance on painting from the posed model seemed both an affront to tradition and an indication of his

Fig. 36. Theodoor Rombouts, *The Musicians.* Spencer Museum of Art, University of Kansas, Lawrence.

ignorance of "that supreme and eternal intellect which is the author of nature" (to quote from Bellori's preface to his *Vite*, in which he lays out the true goal of art). But to Caravaggio's circle of enlightened patrons, his ability to invest secular and religious themes with a new urgency and expressive power through the study of nature constituted the novelty and greatness of his work.[86] This gift for the unconventional later caused problems with the clerics for whose churches his altarpieces were commissioned, and it has provided fodder for the questionable psychoanalytic approach to his art favored by some modern critics. It is worth noting that Giustiniani did not consider Caravaggio a simple realist but placed him in the highest category of painters, alongside Annibale Carracci and Guido Reni, noting that each of these artists had struck his own personal balance between the demands of style and of naturalism ("dipingere di maniera, e con l'esempio davanti del naturale").[87]

Few people were in a better position than Giustiniani to appreciate Caravaggio's real innovations. Not only did he possess an unequaled collection of paintings by the Lombard master, he also played an active role in shaping his career. It was Giustiniani who intervened when Caravaggio's first public altarpiece for the Contarelli Chapel in San Luigi dei Francesi

was rejected, purchasing the work for his own collection and financing a replacement. He was, moreover, a neighbor of Del Monte's and must have observed Caravaggio at work on more than one occasion. Alone among early critics, he is likely to have based his remarks on firsthand experience. It was doubtless Giustiniani who informed the German artist and biographer Joachim von Sandrart, who resided in Giustiniani's palace between 1629 and 1635, that the model who posed for his prized painting of Cupid triumphant over worldly achievement—the *Amor vincit omnia*—was a twelve-year-old youth, whom we can now identify with a high degree of probability as Cecco di Caravaggio, the artist's pupil and occasional lover.[88] But fervent admirer and collector of Renaissance painting and of ancient sculpture that he was, Giustiniani also recognized what many of Caravaggio's biographers—both past and present—have too frequently neglected: that naturalism accounted for only a part, albeit a significant one, of Caravaggio's achievement.

Caravaggio's art was nurtured by Venetian and north Italian naturalism, but it matured in the intellectual environment of Rome, to which he was introduced by Del Monte and his circle of cultivated ecclesiastics. Caravaggio's work for Del Monte, conceived and carried out in the presence of the cardinal's extensive collection of paintings and ancient sculpture and gems (he owned, among other things, the Portland Vase), charts a growing awareness of this new world, and it is marked by an increasing mastery of both the poetic and the representational potential of painting. Not the least significant difference between the two versions of the Lute Player is the more highly focused, more coherent treatment of the allegorical theme in the later picture, due to a new emphasis on dramatic lighting and a strongly pyramidal composition. This transformation—fundamental to Caravaggio's achievement as a religious artist—was not simply a matter of an internal evolution of style. Rather, it should be understood in terms of the dispute over the primary function of art: whether painting, music, or poetry should merely delight through beauty or whether it should edify through clarity of expression.[89] In Del Monte's pictures this question received a novel and compelling answer.

Not surprisingly, to Caravaggio's contemporaries it was not the provocative sensuality of his pictures that seemed so significant but their expressive power—the quality of immediacy acquired by so unpromising a subject as a gypsy fortune teller, a game of cards, or a singer accompanying his vocal performance on a lute. Understandably, the mere presence in Del Monte's collection of these innovative works had a far-reaching impact. One may well question whether artists such as Bartolomeo Manfredi and Valentin would have conceived of painting a concert of youths and a card game as pendant subjects without a firsthand acquaintance with Del Monte's collection and his unique group of Caravaggios. The dispersal of the works Del Monte put together and which his testament was designed to maintain in perpetuity may have made Caravaggio's work more widely known, but it inevitably deprived the pictures of an essential component of their meaning, for it was the cumulative effect of these pictures and the approach to painting they manifest that established Caravaggio's reputation and provided the basis for his subsequent public success.

NOTES

1. The source for this information is Baglione 1642, p. 136. The date of 1595 is derived from the fact that Monsignor Petrignani, with whom Caravaggio is said to have stayed prior to moving to Del Monte's residence in Palazzo Madama, was still in Forlì in 1594.

2. The rumor is reported in Bellori 1672, p. 202; in a marginal note to his copy of Baglione's *Vite*, Bellori relates that Caravaggio had killed a man. All that is certain is that on May 11, 1592, Caravaggio was in his hometown for the settlement of his father's estate; he was then twenty years old.

3. Arpino seems to have had a sideline selling pictures; at least this is the most cogent explanation for his possession of 105 paintings, seized in 1607 by Pope Paul V and given to Scipione Borghese (see De Rinaldis 1935–36). Bellori states that Caravaggio "served" Arpino, by whom he was "employed painting flowers and fruit" ("da cui fù applicato à dipinger fiori e frutti"). He then describes what sounds like a still life owned by Del Monte (see text below). This wording suggests that Caravaggio was employed less as an assistant than as a sort of contracted provider of "genre" pictures.

4. On Del Monte, see especially Spezzaferro 1971, with previous bibliography, and Calvesi 1985.

5. For example, see Baglione 1642, p. 194.

6. Costa's ties to Del Monte's circle of friends were through Ruggero Tritonio, Cardinal Montalto's secretary, to whom in 1606 he willed a picture of Saint Francis, presumed to be an original work by Caravaggio (see Spezzaferro 1974, p. 579). On Cherubini, see Parks 1985, pp. 438–40; on the Mattei picture, see Frommel 1971a, p. 9 n. 31.

7. See Spezzaferro 1971, p. 69. The letters were first published by Gronau 1936, p. 257. Spezzaferro plausibly suggests that the picture in question was a copy of Raphael's *Madonna of Divine Love*.

8. Bellori 1672–96, p. 541; also Sutherland Harris 1977, p. 3.

9. The inventory is published in Frommel 1971a, pp. 30–49.

10. The picture is listed simply as "Una Santa Caterina della Ruota opera d'Annibale Carace" in the inventory (Frommel 1971a, p. 33). It was sold to the Barberini and is described in a 1628 list as showing Saint Catherine with four small figures. It therefore showed the saint's execution. A preliminary drawing at Windsor (no. 1982) is almost certainly for this picture (see Posner 1971a, p. 175 n. 30), which was given by the Barberini to Queen Henrietta Maria (Lavin 1975, pp. 10 no. 83, 89 no. 339).

11. This picture was sold to Antonio Barberini together with Caravaggio's *Cardsharps, Lute Player,* and *Saint Catherine of Alexandria* (Kirwin 1971, p. 55). However, no Saint Jerome of the requisite size (*palmi otto*) occurs in later Barberini inventories, suggesting that this work by Guercino may have been among the gifts made in 1633–34 to the Maréchal de Créquy, in whose 1638 inventory is listed "la Dispute de Sainct Hierosme du Guerchin" (see Boyer and Volf 1988, p. 31 no. CXXIV).

12. These were a Saint Sebastian now in the Pinacoteca Capitolina, Rome, which was purchased by Cardinal Pio together with *The Fortune Teller* and the *Saint John the Baptist* by Caravaggio (Kirwin 1971, p. 55); a half-length Saint Catherine that was purchased by the Barberini (Lavin 1975, p. 30 no. 261); a copy by Reni after Beccafumi; and an Assumption of the Virgin that is described as being in part by Reni (Frommel 1971a, pp. 31–32, 37). The detailed notices on Reni's pictures confirm the reliability of the inventory for works by contemporary artists.

13. The arguments for associating the Hartford picture with the "Ecstasy of Saint Francis" listed in Del Monte's inventory are reviewed by Gregori 1985, pp. 221–24, and Marini 1987, p. 369. The matter is highly problematic, as pointed out by Bologna 1987, pp. 159–67. He proposes identifying Del Monte's picture with a half-length figure of Saint Francis in the collection of Mrs. Barbara Johnson, but I find this unconvincing.

14. The mural is mentioned by Bellori 1672, p. 214, who does not commit himself on its authorship. For a review of opinions on this exceptional autograph work—which through neglect is in a perilous state of preservation—see Marini 1987, pp. 405–407.

15. See Moir 1976, pp. 104–107.

16. Bellori 1672, p. 204.

17. See Mahon 1947, p. 246.

18. Baglione 1642, p. 137. See the interpretation by Mahon 1947, p. 177 n. 51.

19. Spezzaferro 1971, pp. 58, 70.

20. The *Christ on the Cross* and the *Ganymede* attributed to Michelangelo were certainly painted copies of his well-known drawings, possibly by Marcello Venusti. The Raphaels must also have been copies, one possibly of the *Madonna of Divine Love* (see n. 7 above). However, the large Saint John the Evangelist is likely to have been the painting ascribed to Innocenzo da Imola that was later owned by the Maréchal de Créquy and is now at Versailles (see Boyer and Volf 1988, p. 33). Another version of this much-admired picture was owned by Giustiniani. The Leonardo *Mary and Martha* was obviously one of the many compositions of this subject by Bernardino Luini, and it provided the point of departure for Caravaggio's painting now in Detroit (see Gregori 1985, pp. 250–55, for a summary of opinions about this picture). The portrait ascribed to Andrea del Sarto was purchased by the Barberini and given to Queen Henrietta Maria (Lavin 1975, p. 90; see Shearman 1983, p. 205 no. 213); it is by Puligo.

21. An Orpheus, listed in the 1627 inventory (Frommel 1971a, p. 31), and a Nativity on slate that can be identified from the Barberini documents (Lavin 1975, p. 90 no. 346). The Orpheus was purchased by Cardinal Pio in 1628 together with Caravaggio's *Fortune Teller* and *Saint John the Baptist*, but unlike them, it did not enter the Capitoline collections.

22. The Bernardino Licinios, listed under the conventional name of Pordenone in the Del Monte sale of 1628 (Kirwin 1971, p. 55), were a Musica and a Saint Margaret. Additionally, a Saint John the Baptist, appearing without an attribution in the 1627 inventory (Frommel 1971a, p. 33), can be identified in a list of pictures purchased by the Barberini, where it is ascribed to Pordenone (Lavin 1975, p. 89 no. 333). For the confusion between Licinio and Pordenone, see Vertova 1980, pp. 378–79.

23. The "Giorgione" is presumably the unattributed picture of a "musica" listed on f. 583r of the 1627 inventory; it was purchased by the Barberini in 1628 (Lavin 1975, p. 89 no. 333) and was listed as "believed to be by Giorgione." Given by the Barberini to Queen Henrietta Maria (Lavin 1975, p. 22 no. 176a), it is now at Hampton Court as a copy after Dosso Dossi; see Shearman 1983, p. 91, who misidentified it as a similar but different picture listed in a 1623 Barberini inventory.

24. In the letter, published by Heikamp 1966, p. 64, Del Monte refers to a portrait by "my young pupil who works better and more diligently, and more realistically without comparison than that poor Scipione Pulzone." "Poor" refers to the fact that Pulzone had died in the previous year, 1598 (Spezzaferro 1971, p. 80 n. 118). Heikamp tentatively identified this young painter with Ottavio Leone, but this is far from certain. Del Monte owned four paintings by Leone (called Padovanino), but none of these were portraits, and there is nothing to indicate that Leone ever lived in Palazzo Madama. Caravaggio, on the other hand, painted many more portraits than is usually recognized (see the list of lost works in Cinotti 1983, pp. 569–76), and the painter could conceivably be he.

25. See Barocchi 1961, pp. 390ff., and Wind 1974.

26. In Dell'Acqua and Cinotti 1971, p. 164, F. 110e.

27. Vecellio 1590, f. 164v.

28. Wind 1974, p. 33.

29. This suggestion is in Sandrart's biography of Holbein; see Friedlaender 1955, p. 106.

30. See Gregori 1985, pp. 341–44. It is curious that this extraordinary work, which is painted in Caravaggio's unmistakable manner (see Christiansen 1986, pp. 434–36), should still be relegated to a follower by Marini 1987, p. 306—and to such a highly individual one as Alonso Rodriguez.

31. Previous bibliography is thoroughly discussed by Gregori 1985, pp. 228–35; see also cat. 3.

32. The standard work is Egan 1961.

33. Vasari 1568, vol. 3, p. 134.

34. Meijer 1972–73.

35. Vasari 1568, vol. 6, p. 373.

36. Ripa 1603, p. 345.

37. Baglione 1642, p. 136.

38. This aspect of his work is analyzed in greater detail in Christiansen 1986, p. 423.

39. See n. 23 above.

40. See n. 22 above. For other work of this type by Licinio, see Vertova 1980, nos. 45, 107, 147. One of these pictures (no. 147) shows a man holding a money sack behind a woman with a lute, and it bears an inscription reading: "Beautiful maiden, is it any wonder that the sound of gold persuades you as it persuades the gods?"

41. The map is described in the inventory as "Una stampa di una Venetia d'Alberto Duro senza Cornice di Palmi dicesette" (Frommel 1971a, p. 35)—that is, approximately 380 cm. (49½ in.). This is 100 cm. (39⅜ in.) wider than Jacopo de'Barberi's celebrated view of Venice, but allowance must be made for the substantial mount required for the twelve separate sheets that comprise the map. It cannot, in any event, be anything other than Jacopo's map, given the dimensions, the subject, and the logical attribution to Dürer, with whose work Jacopo's was sometimes confused.

42. See Lavin 1975, pp. 89 no. 331, 109 no. 331, 240 no. 629. The last reference provides the most detailed description (earlier inventories are vague about the number and action of the men).

43. See Spear 1971, p. 106. I would like to thank Prof. Spear for the loan of his photograph.

44. Giustiniani ca. 1628, p. 34.

45. The basic treatment is Einstein 1949.

46. Castiglione 1528, p. 120.

47. In a letter dated January 31, 1579, to Giulio Giordani, a minister of Francesco Maria II della Rovere; see Spezzaferro 1971, p. 68.

48. Cited by Spezzaferro 1971, p. 67 n. 51.

49. Giustiniani ca. 1628, p. 31.

50. Einstein 1949, pp. 843–49.

51. The history and relationship of these two pictures is dealt with in detail by Mahon 1990 and Christiansen 1990.

52. Baglione 1642, p. 136.

53. Bellori 1672, p. 204.

54. Salerno 1960, p. 135 no. 8: "Un quadro sopraporto con una mezza figura di un giovane che suona il Leuto con diversi frutti e fiori e libri di musica dipinto in tela alto pal. 4 larg. pal. 5 . . . di mano di Michelang.o da Caravaggio."

55. Wiemers 1986, p. 60. The offers were reportedly made by the Cardinal of Savoy and the Maréchal de Créquy, who owned *The Musicians* (see cat. 3).

56. Baglione 1642, p. 136.

57. This is the highly convincing analysis presented by Marini 1987, p. 387, but it is applied by him to a copy of the Del Monte–Barberini picture; see also Mahon 1990. Franca Camiz has kindly checked the wording in Baglione's manuscript at the Vatican, which does not differ from the printed edition. Wolfe 1985 was the first to note the discrepancies between Baglione's description and the painting in Leningrad, and she pointed out the relevance of the ex-Badminton picture illustrated here (fig. 18).

58. The judgment recorded by Baglione was surely made for effect, and it bears a remarkable similarity to the story Bellori tells about Caravaggio preferring a gypsy model to the example of ancient art.

59. See Christiansen 1990.

60. Bellori 1672, p. 202.

61. See especially Cuzin 1977, pp. 10–11.

62. See the summary of opinions in Cinotti 1983, p. 449.

63. Ripa 1603, p. 345. I am less inclined to accept the erotic interpretation of the bird allowed by Camiz (in Marini 1987, p. 383; 1988, p. 180; and 1989), given Ripa's text and a picture like that of La Hire, discussed below.

64. The notice is reported by Hammond 1985, p. 261; see also Camiz 1988, pp. 174–80.

65. Boyer and Volf 1988, p. 31 no. CXIX.

66. See Posner 1971a, p. 32.

67. On the various versions of this picture, see most recently Marani 1987, p. 195.

68. Shapley 1973, pp. 7–8.

69. Bridgman 1956, p. 20; the passage is cited by Camiz in Marini 1987, p. 382.

70. The madrigals in these two pictures were first identified by Slim 1985, pp. 243–47; see also Camiz and Ziino 1983 pp. 70–75.

71. For these identifications, see Camiz and Ziino 1983, p. 71; Marini 1987, p. 379; and Camiz in Marini 1987, p. 381. The letters are particularly close to Gardane's 1545 edition (see fig. 33), in which one of the madrigals appears on the same page as in the Caravaggio.

72. For a general treatment of the theme of music and love, see Mirimonde 1966–67. Bauch (1956, pp. 254–57) first identified the still-life elements in Caravaggio's picture in Leningrad as vanitas motifs.

73. Cited in Salerno 1984, p. 16; see Berra 1989. Caravaggio may have known this picture.

74. Lavin 1975, p. 53 no. 408, and Hammond 1979, p. 104.

75. Frommel 1971a, p. 48; see also Camiz in Marini 1987, p. 382.

76. Material in this section depends heavily on Chater 1987.

77. Reported in Orbaan 1920, p. 139 n. 1.

78. First by Haskell 1963, p. 29, whose characterization of this event and its relationship to Caravaggio's picture (which we now know was painted for Giustiniani rather than Del Monte) has colored—one might better say prejudiced—all subsequent writing on the subject.

79. As maintained by Gregori 1985, p. 229.

80. From the *Festa fatta in Roma alli 25 di febraio MDCXXXIV* published by Vitale Mascardi, 1635.

81. Annibaldi 1988, p. 108. Annibaldi has amply demonstrated the political side of Aldobrandini's musical patronage.

82. Camiz 1988, p. 172.

83. The plausible identification of the singer as Montoya is due to Camiz 1988, p. 172.

84. Camiz 1983, pp. 100–103; Slim 1985, pp. 248–50.

85. See Mirimonde 1965b, pp. 2–9.

86. The ironic side of Caravaggio's art—evident in his conspicuous use of High Renaissance models and his purposeful inversion of such conventions as the idealized male nude—was attuned to the sophistication of these men. Typically, in Caravaggio's work for private collectors, this side of his art is greatly accentuated. The *Saint John the Baptist in the Wilderness* (Pinacoteca Capitolina, Rome), for example, inverts the premise of Michelangelo's nudes on the Sistine ceiling by taking over the idea but investing it with an assertive naturalism. Curiously, no one has commented on the relationship of the pose of the figure to Taddeo Landini's youths on the fountain outside the Mattei palace (Caravaggio's picture was, of course, painted for Ciriaco Mattei). Yet this fountain was the point of departure for the arresting *Amor*, a painting by a follower of Caravaggio in the castle at Prague, which may serve as a contemporary comment on the tradition to which Caravaggio's nudes belong. See also n. 58 above.

87. Giustiniani ca. 1620, p. 44. On the probable date of this *discorso* of Giustiniani, see Hibbard 1983, p. 345.

88. For Sandrart, see Hibbard 1983, p. 378. The identification of the model as Cecco di Caravaggio, "his owne boy or servant thait laid with him," comes from a notice of an Englishman, Richard Symonds (Wiemers 1986, p. 60). Wiemers interprets the notice as proof that contemporaries viewed the work in terms of Caravaggio's homosexuality, but this seems to me to impose a twentieth-century concern on a rather casual observation. Symonds was, after all, impressed by two facts: the inordinate sum of money that had been offered for the picture (two thousand doublons) and a piece of gossip or biographical detail, of the sort still popular among tourists today. Incidentally there is no indication what he thought of this tidbit. It is, after all, one thing to note that the model was reputed to be the pupil-lover of the artist and another to interpret the picture in terms of that fact. For Sandrart it was the specificity of the *Amor*—which is to say the naturalistic treatment—that seemed noteworthy. Symonds's enigmatic telescopic comment, "Checco di Caravaggio he called many he painted was his boy," surely refers to the use of this same model in a number of paintings, a practice noted by Frommel (1971b, pp. 47–53). Frommel attaches a biographical significance to Caravaggio's use of specific models, but in this case his interpretation carries no more weight than the notion that Caravaggio's *Death of the Virgin* is really about the artist's relationship with the notorious Lena (whose character, as presented in most books on the artist, is nothing short of fiction). The one picture in which the iconography is likely to relate directly to Caravaggio's love life is the *David with the Head of Goliath* in the Galleria Borghese. Manilli 1650, p. 67, reported that in this picture Caravaggio portrayed himself and in the *David* he "depicted his Caravaggino"—which I take to mean Cecco di Caravaggio, shown a few years older than in the *Amor*. (I believe, like Frommel, that the *David* is a late Roman work, for its style and technique announce the *Seven Acts of Mercy* rather than the *Martyrdom of Saint Ursula*; the current late date usually assigned it has more to do with a romantic, biographical reading of the picture than an analysis of its style.) It is not difficult to envisage the *David and Goliath* as potentially carrying the same sort of amatory allusions—albeit inverted—as *Judith Beheading Holofernes* sometimes does. The notice of Cecco has, of course, an altogether independent importance in confirming that Cecco di Caravaggio actually worked with Caravaggio and that if he was about twelve when the *Amor* was painted, he must have been born about 1588.

89. Discussions about the primary function of art are too numerous to cite, but it may be worth noting what Vincenzo Galilei has to say about music in his 1581 *Dialogo della musica antica e della moderna*: "Consider each rule of the modern contrapuntists. . . . They aim at nothing but the delight of the ear, if it can truly be called delight. They have not a book among them for their use and convenience that speaks of how to express the conceptions of the mind and of how to impress them with the greatest possible effectiveness on the minds of the listeners. . . . Their ignorance and lack of consideration is one of the most potent reasons why the music of today does not cause in the listeners any of those virtuous and wonderful effects that ancient music caused."

CATALOGUE

Caravaggio (Michelangelo Merisi)

Caravaggio 1571–Porto Ercole 1610

1. THE FORTUNE TELLER

About 1594–95
Oil on canvas; 115 x 150 cm. (45¼ × 59 in.)
Pinacoteca Capitolina, Rome

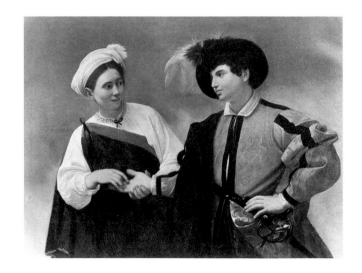

THE THEME of a young man duped by a gypsy fortune teller who steals his ring as she reads his palm was treated by Caravaggio twice—first in this picture, which is listed in Cardinal del Monte's inventory of 1627 ("Una Zingara del Caravaggio"; Frommel 1971a, p. 31), and then, a year or two later, in a painting now in the Louvre that was a gift of Prince Camillo Doria Pamphili to Louis XIV in 1665 (Cuzin 1977, pp. 3–4). As with the two versions of *The Lute Player*, so here the success of the first picture must have occasioned the commissioning of a more tightly constructed, highly focused second version. In both the theft of the ring, described by Giulio Mancini (ca. 1620, p. 109), Caravaggio's early biographer, is scarcely visible. For Mancini and Gaspare Murtola, whose madrigal of 1603 is quoted in the introductory essay, the key to the moral of the pictures lay in the appearance of the gypsy, whose beauty has deceived the youth. Caravaggio thus comments both on the thieving reputation of gypsies and on love and the gullibility of youth, a theme taken up later in a Guercinesque drawing in the Louvre that shows a blindfolded cupid hovering over a youth whose fortune is being told by a beautiful gypsy (see Cuzin 1977, pp. 29–30).

Wind (1974, pp. 31–32) has noted the resemblance of Caravaggio's treatment to a late sixteenth-century French engraving of a commedia dell'arte scene, and he has emphasized the importance of theatrical conventions in shaping Caravaggio's conception. Gypsies provided material for sixteenth-century theater and literature and were even the subjects of popular songs (Cuzin 1977, p. 22). The 1588 celebrations for the marriage of Ferdinando de'Medici to Christine of Lorraine included the performance of the comedy *La Zingara* (The Gypsy), and by 1658 the performance of *zingarate* (gypsy pieces) had to be forbidden in Rome. Caravaggio's pictures—the first isolated treatment of the theme in Italian art— could not have been conceived without this established vogue, for the Del Monte version was almost certainly painted for sale on the market: Mancini, writing about 1620, tells that out of necessity Caravaggio sold a picture of this subject for the meager sum of eight scudi; this story can hardly apply to the Louvre version, which must have been painted after Caravaggio had moved into Palazzo Madama on Del Monte's invitation.

The existence of the Louvre picture makes it difficult to be certain to which version early sources sometimes refer. Murtola's madrigal could apply to either the Del Monte or the Louvre version, while Mancini may have known both (on this, see Mahon 1988, pp. 23–24). The Del Monte picture was sold in 1628, almost certainly to Cardinal Carlo Emanuele Pio; it was acquired in 1750 by Pope Benedict XIV from Prince Don Gilberto Pio for the newly formed Pinacoteca Capitolina. Any doubts about the Del Monte provenance of the Capitoline picture were laid to rest by the discovery of a stamp of a coat of arms on the reverse of the original canvas (figs. 37 and 38); the same stamp is found on the reverse of

The Cardsharps (cat. 2) and Guido Reni's *Saint Sebastian* (Pinacoteca Capitolina, Rome), both of which also belonged to Del Monte but were separated after their sale in 1628. This discovery, together with the cleaning undertaken in 1984, has confirmed Caravaggio's authorship, previously doubted by a number of scholars (for a review of opinions prior to the cleaning, see Cinotti 1983, p. 520; for the cleaning, see Tittoni Monti 1989).

The picture is not in good condition. The final glazes have been lost, and the granular surface (due to the use of sand in the preparation) further compromises legibility. Some idea of the original quality of execution can be gained from the glove stuffed into the sword guard and, to a lesser degree, the left sleeve of the youth. There is a prominent pentimento to the right of the youth's jacket, and the gypsy's shawl has lost any delicacy it once had. Cleaning has revealed the ring, previously not visible.

Whether this picture, like *The Cardsharps*, was purchased by Del Monte from the picture dealer Maestro Valentino, whom Baglione credits with having sold "some pictures" by Caravaggio, cannot be ascertained, but it is possible. Alternatively, Del Monte may have sought out the picture following his purchase of *The Cardsharps* (Mahon 1988, p. 24). *The Fortune Teller* seems to be the earlier of the two works and may indeed have been painted in the workshop of the Cavalier d'Arpino: an underlying image of the Virgin, visible in X rays, is closely related in style to Arpino's own work and has sometimes been attributed to him, although it could well be by Caravaggio himself. The extraordinary quality of a casual, fleeting street scene recaptured in the artist's studio—as though the picture had, to a degree, been created as a demonstration of Caravaggio's revolutionary method of working directly from life, described by Bellori (1672, p. 203)—has been admirably analyzed by Gregori (1985, p. 220). KC

2. THE CARDSHARPS

About 1595
Oil on canvas; 91.5 × 128.2 cm. (36 × 50½ in.)
Kimbell Art Museum, Fort Worth

A WELL-DRESSED dandy is shown engaged in a game of cards with a cardsharp who, in response to a signal from his accomplice, draws a winning card from his waist. On the table, which is covered with an Anatolian carpet, is a backgammon board with a dice shaker.

In his biography of Caravaggio, Baglione recounts how the artist was saved from poverty by the charity of some interested amateurs "until the picture dealer Maestro Valentino at San Luigi dei Francesi sold some pictures, and it was in this way that Caravaggio became known to Cardinal del Monte." Bellori, writing a half-century later, notes that *The Cardsharps* "was bought by Cardinal del Monte who, being a great lover of painting, rescued him, giving the artist an honored place in his household." Caravaggio's career in Rome would thus appear to hinge on *The Cardsharps*, which occasioned his discovery by Del Monte. Although a later date for the picture has been argued on the inadequate basis of a photograph made before the picture was sent to Paris in 1891/92 and disappeared (see Cinotti 1983, p. 555), Bellori's account cannot be easily dismissed, and his characterization of the work as belonging to Caravaggio's first, "Giorgionesque" phase can now be confirmed by the evidence of the painting itself. The doublet on the youth at the left is painted in a manner reminiscent of Savoldo, and there is not yet any sign of Caravaggio's typical raking light with its strong shadows. Significantly

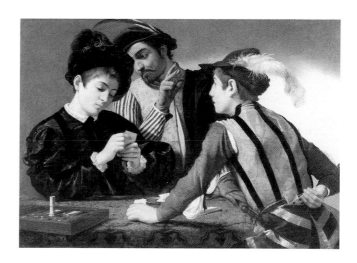

Figs. 37–38. Stamps from the backs of the original canvases of *The Cardsharps* (left) and *The Fortune Teller* (right).

like Caravaggio's other early pictures—including *The Fortune Teller*—the picture is painted on a gray ground found in Lombard painting and employed by his teacher Simone Peterzano. A date about 1595 therefore seems reasonably certain.

According to Baglione, more than one painting was sold to Del Monte by Maestro Valentino, and it is conceivable he had something to do with the purchase of *The Fortune Teller* as well as *The Cardsharps*. The latter stands out among Caravaggio's early works for its ambitious conception. It was one of his most influential compositions, being copied almost from the outset. Some of these copies gained a spurious reputation as originals: as early as 1621 the amateur-critic Giulio Mancini was asked to give his opinion in a dispute about the status of one such copy owned by the Marchese Sannesio. More than thirty copies are known today (see Moir 1976, pp. 105–106). The enormous popularity this subject later enjoyed throughout Europe can be traced to this picture and its success among the northern followers of Caravaggio in Rome.

The moralizing subject and its relation to theatrical conventions are discussed in the introductory essay. In addition to the various northern works usually cited as possible sources for Caravaggio's treatment, Giulio Campi's picture of a mixed company playing chess (Musei Civici, Turin) should be mentioned as a Lombard precedent. Caravaggio was however, the first to make cheating the primary subject and to treat it in terms of everyday life.

The picture has sometimes been considered a pendant to *The Fortune Teller* (see Ottino della Chiesa 1967, p. 88 n. 14; and Frommel 1971b, p. 39), but although their moralizing subjects are related, their dimensions differ significantly. In the 1627 inventory of Del Monte's collection both pictures are listed in the same room, and both have the ubiquitous black frames Del Monte seems to have favored. The picture was sold on May 7, 1628, to Cardinal Antonio Barberini together with *The Lute Player* (cat. 5) and the *Saint Catherine of Alexandria* now in the Thyssen Collection, Lugano. It remained in the collection of the Barberini until 1812, when the picture passed into the possession of Don Maffeo Barberini-Colonna di Sciarra; about 1895 it was sold in Paris by his son Prince Maffeo Sciarra to an unknown collector. Only in 1987 did the picture reappear on the art market. A stamp of a coat of arms on the reverse of the original canvas, identical to that found on Del Monte's *Fortune Teller*, was discovered during relining, definitively proving that this is the autograph version owned by Del Monte (figs. 37 and 38). For a full account of the history of the picture and an analysis of its technical features, see Mahon (1988) and Christiansen (1988). KC

3. THE MUSICIANS

About 1595
Oil on canvas; 87.9 × 115.9 cm. (34⅝ × 45⅝ in.)
The Metropolitan Museum of Art. Rogers Fund,
1952 52.81

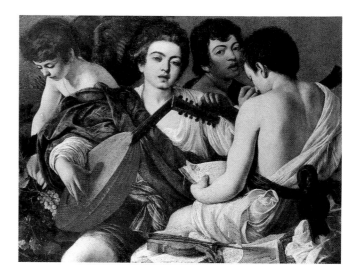

ACCORDING TO BAGLIONE (1642, p. 136), Caravaggio painted "a concert, with some youths portrayed from nature very well" immediately after receiving quarters in Palazzo Madama, Cardinal del Monte's residence. The Metropolitan's picture, which was discovered only in 1952 (Mahon 1952), is now universally identified with this picture—not, however, without some surprise being voiced about the "overbearing taste for pagan allegory" it exhibits (Longhi 1952, p. 19). What now seems clear is that Del Monte's interest in *The Fortune Teller* and *The Cardsharps* stemmed from their combination of a naturalistic style and a moralizing theme. His later commission of *The Lute Player* demonstrates that for *The Musicians* he envisaged not a depiction of a contemporary concert but an allegory of Music and Love (symbolized by the cupid gathering grapes) conceived in naturalistic terms.

In a marginal note in his copy of Baglione's *Vite*, Bellori remarked on the flatness of the composition of *The Musicians*, which resulted from Caravaggio's piecemeal construction of the work from individually posed models. It is likely that the cornetto player is a self-portrait, and it is possible that the lutenist is also a specific individual in Del Monte's household. Caravaggio's manner of working from life reflects his training in

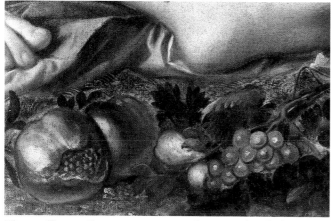

Fig. 39. Simone Peterzano, *Venus and a Satyr* (detail of still life). Piero Corsini, Inc., New York.

Lombardy, and it is worth comparing the grapes in this picture with those in a work by his teacher Simone Peterzano, showing Venus and a satyr, recently identified by Mina Gregori (Piero Corsini, New York; fig. 39).

The early history of the picture can now be reconstructed with some precision. On May 8, 1628, it was sold, together with a painting of a carafe of flowers by Caravaggio and a music piece by Bernardino Licinio. Its eventual purchaser may well have been Cardinal Antonio Barberini, since according to a 1634 report he gave a painting by Caravaggio "purchased from the Vigna Ludovisi" to the Maréchal de Créquy together with a work by Lanfranco (erroneously stated to have been purchased from the "Vigna" as well, whereas it was commissioned by the Barberini; see Boyer and Volf 1988, pp. 26, 36 n. 34, 39 n. 73). The Vigna Ludovisi refers to Del Monte's casino near the Porta Pinciana, which he sold to Cardinal Ludovisi in 1621. *The Musicians* appears in a 1638 inventory of Créquy's collection and was subsequently owned by Richelieu and by the Duchesse d'Aiguillon (Boyer and Volf 1988, p. 31). A yellow inscription (in capitals) with Caravaggio's name, formerly visible in the lower left corner, is similar to that on another painting that belonged to Créquy, the *Supper at Emmaus* by Veronese in the Louvre (this information was kindly furnished by Lizzie Boubli). Créquy's interest in Caravaggio's work is demonstrated by his unsuccessful attempt to purchase the *Amor vincit omnia* from Vincenzo Giustiniani (see Wiemers 1986, p. 60).

The Duchesse d'Aiguillon's 1675 inventory notes that the canvas had been glued to a wooden support,

which may have contributed to the poor condition of the painting today. Even the better-preserved passages, such as the head of the lutenist and the still life, have lost much of their subtlety, and the lute is scarcely more than a shape: the strings have been obliterated and the shadows cast by the right hand of the player are but smudges (see the comparable passage in the Del Monte *Lute Player*, cat. 5). The violin and upturned page of music have been reconstructed on the basis of a later copy; none of the musical scores are legible. However, as a result of this drastically compromised state, it is possible to appreciate the manner in which Caravaggio reworked passages to adapt an initially more prosaic image into an elegant and more abstracted allegorical statement. The lutenist's shirt and sash, for example, were repainted with more rhythmically disposed drapery. In a real sense, the picture was an experiment in a kind of painting that placed new demands on Caravaggio, and the lessons derived from it provided the basis for some of his most poetic works, including the two Lute Players.

A biographical or homoerotic interpretation is often attached to this picture. The compellingly sensual quality of the image should not be minimized, but it is doubtful that the picture was intended to convey an explicitly sexual meaning. Caravaggio's bisexuality can be established with some certainty (see Wiemers 1986); Del Monte's sexual character is not known, and what bearing, if any, it had on this picture must be based on conjecture. KC

4. THE LUTE PLAYER

About 1595–96
Oil on canvas; 94 × 119 cm. (37 × 46⅞ in.)
Inscribed on open part-book: *Voi sapete ch'*;
on closed part-book: *Bassus*
State Hermitage Museum, Leningrad

CARAVAGGIO'S *Lute Player* in Leningrad is perhaps the masterpiece of his early, "Giorgionesque" phase—to employ the term by which the artist's contemporaries and later critics understood his first works: "pure, direct, and without those strong shadows he later employed" (Bellori 1672, p. 202). By the same token the picture substitutes for the softer lighting of the three earlier works in Del Monte's collection the hallmark shaft of light that both illuminates the figure, accentuating the contrasts of light and shade, and sharply divides the back wall diagonally. The idealizing premise that caused Caravaggio such difficulties in *The Musicians* is here fully mastered, and the figure is at once palpably present yet psychologically removed. His apparent androgyny has been held to be emblematic of a religious-cabalistic significance (Calvesi 1985, pp. 264–67), an explanation that seems strained and inapposite, and as a symbol of harmony (Spezzaferro 1971, p. 87). It has also been interpreted as indicative of the presumed homosexual orientation of the artist (see especially Posner 1971b, pp. 303–304). Most convincing is the proposal that the model was a male soprano—a castrato—and that his androgynous features are characteristic of these singers, whose rising popularity dates from the last two decades of the sixteenth century, following the 1589 bull of Sixtus V authorizing their recruitment for the Sistine Chapel choir (see Rosselli 1988, p. 146; for a discussion of Del Monte's support of music and his own resident castrato, a Spaniard named Pedro Montoya, see Camiz 1988, with earlier bibliography).

The musician is shown accompanying his vocal performance of one of the amorous madrigals in the part-book in front of him (for the identification of the madrigals, see Camiz and Ziino 1983, pp. 70–75; Slim 1985, pp. 243–44; and the appendix). The violin is a standard prop in music pictures, rather than an open solicitation to the viewer (Posner 1971b, p. 303). The still life of flowers and fruit is a traditional vanitas element, alluding here to the transitory nature of love, whose message is carried on the fleeting notes of the music,

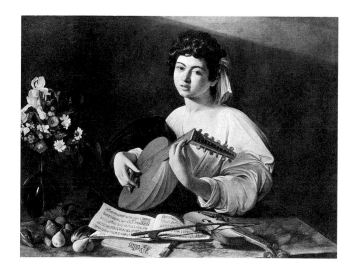

5. THE LUTE PLAYER

About 1596–97
Oil on canvas; 100 × 126.5 cm. (39⅜ × 49¾ in.)
Inscribed on part-book: *Bassus*; lower right: *F.13*.
Private collection

I N THE seventeenth century this arresting picture of a singer accompanying himself on a seven double-course lute was one of Caravaggio's best-known works, apparently even overshadowing the earlier, variant composition now in Leningrad (cat. 4). It is described by both Baglione (1642, p. 136) and Bellori (1672, p. 204), and it can be traced from the collection of Cardinal del Monte through the various inventories of the Barberini family until its sale to the father of the current owner in 1948 (see Mahon 1990; and the introductory essay). The *F.13.* in the lower right corner is the number assigned the picture in 1817 as part of the Barberini *fidecommesso* (entailment). Curiously, none of the early biographical sources hint at the existence of the version at Leningrad, then in the Giustiniani collection, though that work must also have been well known. This omission led to the notion among modern writers that Caravaggio had painted only one picture of this theme—which, paradoxically, came to be associated exclusively with the (now) better-known Leningrad painting (see Cinotti 1983, pp. 447–48, for a review of opinions). Friedrich von Ramdohr was the first to note the existence of both paintings in his 1787 account of paintings and sculpture in Rome (p. 285), and he demoted the Del Monte–Barberini *Lute Player* to the status of a copy (though

played on a damaged lute. It is in this context that the cucumber and overripe figs and pears assume a potentially sexual significance. The marble slab that serves as a table is perhaps intended to enhance the classical-allegorical allusion of the picture, so different in feeling from the more prosaic character of contemporaneous paintings of musicians.

Interpretation of the picture has been hampered by the belief that it was painted for Cardinal del Monte and only later acquired by Caravaggio's other great patron, Vincenzo Giustiniani, but it can now be demonstrated that Del Monte owned not this picture but a second version of the composition (cat. 5). It is likely that Giustiniani had seen Caravaggio's work in Del Monte's residence and was inspired by the pictures he saw (including *The Musicians*) to commission *The Lute Player*. It is listed in a 1638 inventory of Giustiniani's collection and remained in the family's palace until its purchase for Czar Alexander I in 1808.

The carefully conceived composition marks a significant advance over *The Musicians*, and the marvelously lucid arrangement of the drapery is comparable to that in Caravaggio's ceiling decoration of Del Monte's *camerino* in the Casino Ludovisi, which is datable on external evidence after November 1596. The still-life details had a notable impact on later paintings in Rome, including Cavarozzi's *Lament of Aminta* (cat. 12). The carafe of flowers—a vanitas element—was imitated in a painting of the Three Ages of Man by Pietro Paolini, a Lucchese follower of Caravaggio (see Giusti Maccari 1987, p. 89).

KC

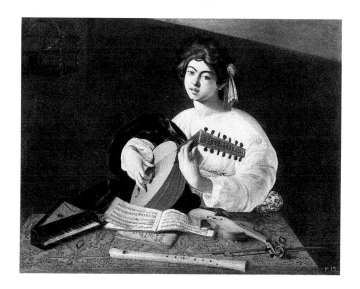

without any immediate sequel). Longhi (1913, p. 161 n. 1) delivered what proved to be a coup de grace by ascribing the picture to Carlo Saraceni, an implausible attribution that nonetheless prejudiced any proper evaluation, even after the publication of the Del Monte and Barberini inventories (Frommel 1971a, pp. 30–49; Lavin 1975). Crucial to a revaluation was the discovery of the actual payment for Del Monte's picture by Antonio Barberini in 1628 (Wolfe 1985, p. 452 n. 16), establishing unequivocally the existence of two separate versions by Caravaggio. *The Fortune Teller* (cat. 1) suffered a similar fate. Despite this confusion, a comparison of the two versions of *The Lute Player* reveals that they differ in style as well as in detail—the Del Monte picture includes different as well as additional instruments (a spinettina and tenor recorder), it shows different madrigals (see appendix), and the still life of fruits and flowers has been suppressed and a caged songbird introduced (an obvious allusion to *musica naturalis*). The stepped-up contrasts of light and shadow and the looser brushwork in the Del Monte picture forecast works of Caravaggio's early maturity, such as the *Saint Catherine of Alexandria* in the Thyssen Collection, Lugano (fig. 25)—a comparison made by Bellori in his description of the picture. These features alone would suggest a date about 1596–97. Additional evidence for this date is provided by the carpet-covered table (the carpet is a Ushak type) placed parallel rather than diagonal to the picture plane, its receding edges defining the foreground space. It marks a middle term between the game table in *The Cardsharps* (cat. 2) and that in *The Supper at Emmaus* (National

Gallery, London), with its studiously arranged still life of food and drinking implements. Caravaggio's interest in perspective was evidently stimulated by his residence with Del Monte, whose brother was then writing a treatise on the subject, and this may partly explain the advances in spatial clarity found in *The Lute Player* (on this subject, see Gregori 1985, pp. 232–33). However, it is worth noting that there is no single vanishing point: the side wall is projected from a different position. In this respect Caravaggio remained faithful to a north Italian empirical approach to spatial projection. Far more remarkable than the resemblance of the Del Monte *Lute Player* to the Giustiniani version is the degree to which Caravaggio revised the earlier composition to create a more focused, if less poignantly affective work.

Antonio Barberini's purchase of *The Lute Player* was doubtless motivated in part by his concern with music, and it is interesting to note that he seems also to have acquired *The Musicians* after the Del Monte sale. That picture was given to the Maréchal de Créquy in 1634 as part of the Barberinis' pro-French political policy (see cat. 3). In 1642 Carlo Magnone, the undistinguished assistant of Andrea Sacchi, was paid twenty-two scudi to make copies of *The Cardsharps* and *The Lute Player*, obviously as gifts, since the copies are not recorded in subsequent Barberini inventories (Lavin 1975, p. 9 doc. 78). In recent literature confusion has arisen between the copy Magnone painted and the original picture owned —and retained—by the Barberini (e.g., Moir 1976, pp. 85, 123 n. 184; Marini 1987, pp. 377–78, 381). KC

Sixtus Rauchwolff

Augsburg about 1556–after 1619

6. LUTE

1596
Spruce, ebony, rosewood; length 74 cm. (29⅛ in.)
Labeled: *Sixtus Rauchwolff Auguspergus A° 1596
Manumprope* and *Matthias Hummel Lauten- und
Geigenmacher in Nürnberg Anno 1694 zugericht.*
The Metropolitan Museum of Art. Gift of Joseph
W. Drexel, 1889 89.2.157

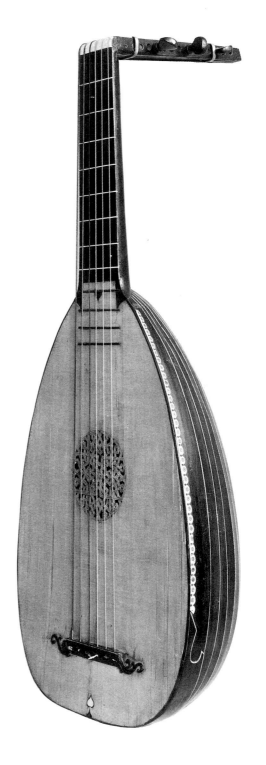

ALTHOUGH RESTRUNG and refretted as a six-string
guitar, this lute is among the types depicted by
Caravaggio and his contemporaries. Many—perhaps
most—lute makers in Italy about 1600 were German
immigrants, and no clear distinction exists between
south German and Italian lutes save occasionally in
choice of materials. All typically incorporate a carved
geometric rosette in the top; the designs of these fret-
work rosettes recall the lute's Near Eastern origin. In
European iconography the lute serves as an emblem of
love and concord; often it appears in pictures of court-
ship or seduction. Capable of playing counterpoint as
well as chords and melodies, the lute enjoyed an exten-
sive solo and ensemble repertoire and was commonly
used to accompany a singer with chordal harmonies or
polyphonic lines. Italian madrigals were frequently per-
formed in arrangement for solo singer with the remain-
ing vocal lines transcribed for the lute. In the late
sixteenth century the luthier Sixtus Rauchwolff (or
Rauwolf) provided lutes such as this one for the Stutt-
gart Hofkapelle and for the Fugger family, who assem-
bled a renowned collection of fine instruments. LL

Nicolò Amati

Cremona 1596–1684

7. VIOLIN

1669
Spruce and maple; overall length 59.1 cm. (23¼ in.)
Labeled: *Nicolaus Amatus Cremonen. Hieronym. Fil.*
Ac Antonij Nepos Fecit 1669
The Metropolitan Museum of Art. Gift of Evelyn Stark,
1974 1974.229

THE FAMINE and plague that decimated Cremona about 1630 spared few violin makers, and of the Amati family only Nicolò survived to carry on the work of his forebears. In the sixteenth century Nicolò's grandfather Andrea Amati, his father, Girolamo, and his uncle, Antonio, defined the form of the Baroque violin. Baroque violins differ from modern ones chiefly in having shorter, thicker necks (protruding straight from the body rather than angled back), shorter fingerboards and flatter bridges, gut rather than steel strings, and lower string tension, resulting in a softer, less brilliant sound. The Museum's example was modernized in the nineteenth century, when it was awarded to Paul Julien, prizewinner at the Paris Conservatoire; it was restored to Baroque configuration in 1977. The geometrically inlaid fingerboard and tailpiece, recalling the violin in the Giustiniani *Lute Player* (cat. 4), are more typical than the Del Monte version's curvilinear decoration, which would have been difficult to inlay, especially at the corners of the spruce top. The F-holes of Caravaggio's violins are exaggerated in shape, as are the flutings of his scrolls. Caravaggio's instruments, even when copied from real models, are not painted with photographic accuracy; they function instead as symbols in his complex iconography. LL

German, 17th century

8. TENOR RECORDER

Maple; length 56.5 cm. (22¼ in.)
The Metropolitan Museum of Art. The Crosby Brown
Collection of Musical Instruments, 1889 89.4.3133

TURNED AND BORED on a lathe from a single billet of
wood rather than assembled from several sections as
was the practice later in the Baroque era, this recorder is
typical of seventeenth-century examples in both appear-
ance and internal profile. Twin finger holes for the low-
est note allow alternate hand positions; either the left
or right hand can be lower, and the unused hole (here
the left-hand one) is plugged. (The playing position de-
picted in *The Lament of Aminta* [cat. 12], by Bartolomeo
Cavarozzi, is wholly unrealistic, as the boy's fingers
do not cover the holes and both of the lowest holes
appear to be unplugged.) This recorder plays nominally
in the key of C but sounds about a semitone higher than
modern pitch. Two burned rings around the beaked fipple
show where hot wires clamped a crack as they cooled
and shrank. The instrument may have been one of a
homogeneous consort of recorders of different sizes, or
it may have been used in ensemble with other types of
instruments such as plucked and bowed strings. A lim-
ited repertoire, mainly variations on popular tunes,
exists for solo recorder. LL

Girolamo Zenti

Viterbo–Paris 1668

9. SPINETTINA

Before 1668
Ebony, ivory, spruce or fir; width 45.1 cm. (17¾ in.)
Signed on keyboard: *G° Zi*
The Metropolitan Museum of Art. The Crosby Brown
Collection of Musical Instruments, 1889 89.4.1227

INTENDED AS a plaything for an aristocrat, possibly a child, rather than for serious professional music-making, this tiny polygonal spinet evidently once belonged to Grand Duke Ferdinando de'Medici. In a Florentine court inventory of 1700 a Zenti spinet of this description is mentioned as being playable while it rested on one's stomach, perhaps while the player reclined in bed. The spinet was formerly protected by a separate outer case covered and lined with crimson damask trimmed with gold ribbon. The lowest key of this plucked instrument, a member of the harpsichord family, sounds G above middle C. The soundboard lacks a sound-hole rosette like that shown in the similar spinettina in the Del Monte *Lute Player* (cat. 5). Caravaggio's model, also removed from its outer case, had more notes than Zenti's, so its keys were presumably even narrower. Girolamo Zenti was much in demand as a harpsichord builder; he worked in London, Paris, and Stockholm as well as in Italy, where this instrument was made, probably in Rome or Florence. LL

German, 17th century

10. CORNETTO

Leather-covered wood; length 58 cm. (22⅞ in.)
Stamped on edge of bell: *HWK*
The Metropolitan Museum of Art. Gift of The
University Museum, University of Pennsylvania,
1953 53.56.9

THE GENTLY curved cornetto, usually carved of
wood and wrapped with black leather, is blown
through a cup-shaped mouthpiece like that of a trumpet
(absent in this example) but has finger holes like those
of a recorder. Its name derives from its resemblance to
an animal horn (*corno*), and it can figure iconographically
as a symbol of pastoral music. However, in practice the
cornetto is capable of surprising subtlety and virtuosity;
it blends well with voices and strings, and in the six-
teenth century its solo repertoire overlapped with that
of the violin. Cornetti figured prominently in church,
court, and civic music as well as in less formal ensembles
gathered for entertainment. As with most Renaissance
and Baroque instruments, cornetti were constructed in
different sizes for playing at various pitches. The exam-
ple shown here, decorated with faint embossing, is
about the same length as a tenor recorder and plays in
the same range. Cornetti similar to this one appear in
Caravaggio's *Musicians* (cat. 3) and Gentileschi's *Lute
Player* (cat. 15). LL

Bartolomeo Passerotti

Bologna 1529–1592

11. PORTRAIT OF A LUTE PLAYER

1576
Oil on canvas; 77 × 60 cm. (30⅜ × 23⅝ in.)
Inscribed: *Anno Iubilei Bon M D LXXVI*
Museum of Fine Arts, Boston. Bequest of
Mrs. William de Forest Thomsom

BARTOLOMEO PASSEROTTI set up his studio in Bologna around 1560 and became the most active portraitist in that city. He was greatly admired by later Bolognese artists such as Reni, who is said to have remarked that his portraits "could stand as equals to those of the Carracci" (Malvasia 1678, I, p. 243). This portrait of a musician, dated 1576, "the year of the jubilee," was painted at the height of Passerotti's career.

Although the sitter is unknown, written accounts relate that Passerotti painted identifiable musicians on several occasions. Malvasia, the seventeenth-century biographer of Bolognese artists, describes a group portrait of the four Monaldini brothers in his own collection. This work has been identified with a picture in a Scottish private collection (Fortunati Pietrantonio 1986, p. 547) in which three of the four musical brothers are shown while performing: one plays a lira da braccio accompaniment to their singing. All three have their mouths slightly open with their teeth showing, thus following Giovanni Camillo Maffei's prescriptions in his 1562 discourse on singing (Bridgman 1956, p. 20). The fourth holds a lute and points at his brothers in a demonstrative gesture often employed rather mechanically by the artist to draw the viewer into the picture (Heinz 1972).

Malvasia applauds Passerotti for giving to each person portrayed "that action and that gesture which was most particular and frequent to the nature and the genius of the subject; and in that guise not portraying them still and insensate but in action and in movement and animating them" (Malvasia 1678, I, pp. 242–43). He links this ability to ancient practice and in particular to the work of Apelles. Expanding on his interpretation of Passerotti's portraiture, Malvasia mentions a work by Tintoretto of a musician who lightly touches a lyre, and one by Agostino Carracci "in the same taste as the Tintoretto" with the mouth open and the hand gesturing beautifully. A work in a like spirit is Annibale Carracci's *Portrait of the Lute Player Mascheroni* (Staatliche Kunstsammlungen, Dresden; fig. 30), where the artist has captured his friend in a sober mood, his thumb lightly on the strings.

Passerotti's lute player is portrayed in a similar fashion. The musician is shown three-quarter length, leaning against a table and just touching the strings of his instrument. Unfortunately, neither the text nor the music on the sheet is legible, robbing us of evidence for an identification. The musician's costume resembles those of the Monaldini brothers—and other Bolognese gentlemen portrayed by Passerotti—with its soft white lace collar and cuffs. This is not a theatrical costume and there is no hint of a public performance. Rather, the artist portrays an individual engaged in an action that characterizes him. AB

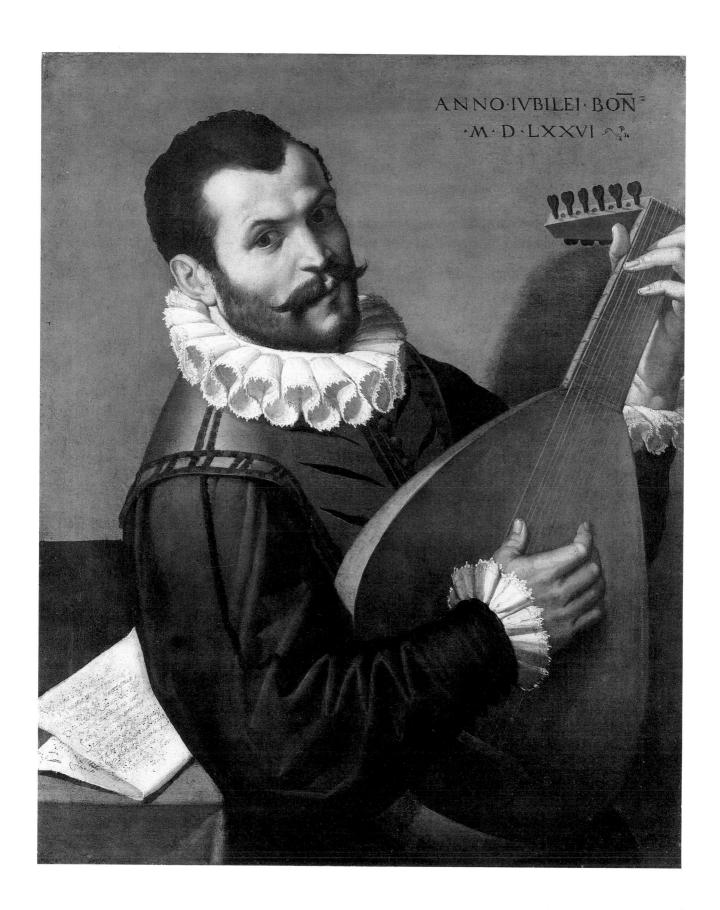

ANNO·IVBILEI·BON̄
·M·D·LXXVI·

67

Bartolomeo Cavarozzi

Viterbo 1590–Rome 1625

12. THE LAMENT OF AMINTA

About 1610–15
Oil on canvas; 82.5 × 106.5 cm. (32½ × 41⅞ in.)
Inscribed, on music, with verses of madrigals
(see below and appendix)
Private collection, Italy

THE SUBJECT of this picture has only recently been identified on the basis of the music, so self-consciously displayed to the viewer (see Camiz 1983, pp. 100–103; Slim 1985, pp. 248–51). The cantus lines— "Dolor, che sì mi crucii" and "Bello è dolce morir"— are from madrigals by Erasmo Marotta (1578–1641) for his musical adaptation of Torquato Tasso's verse drama *Aminta*. The depiction reproduces pages 16 and 17 of Antonio Gardane's edition (Venice, 1600), entitled *Aminta musicale: Il primo libro di madrigali a cinque voci, con un dialogo a otto*. The lyrics are taken from act 3, scene 2 of Tasso's pastoral work (see appendix). The shepherd Aminta has just learned that his beloved nymph Silvia has been devoured by wolves. When the tragic news is brought to him by the messenger Nerina, he is with his companion, Tirsi, and Silvia's companion, Daphne. The verses depicted express his penetrating sorrow at this announcement. (Another madrigal by Marotta, from the same edition but based on a different poem by Tasso, is also shown.)

The laurel-crowned shepherd, mournfully playing the recorder, is presumably Aminta, while the figure at the right, leaning on a tambourine, is probably the nymph Daphne (Camiz 1983, p. 102; Camiz 1985, p. 267) or, less likely, Aminta's male companion, Tirsi (Slim 1985, p. 251). A precise identification is complicated by the generic nature of the costumes, which recall Caravaggio's work, and by the absence of any setting or props beyond the grapes. When performed, Tasso's play was staged with sets representing woods and meadows (the woodcut illustrations to the 1583 and 1590 editions of *Aminta* reflect performances in Ferrara between 1573 and 1583; see Cavicchi 1971, p. 58). Marotta's madrigals are, however, based on dialogues from various scenes in *Aminta*, and they could have been performed either independently or as *intermedi* in a recitation of the play, such as the one recorded at the villa of Cardinal Bevilacqua in 1609 (Orbaan 1920, p. 279; also Camiz 1983, p. 103).

Rather than depicting a precise moment in the play, the picture may be intended to evoke Aminta's effort to assuage his sorrow by playing the bagpipe, an episode illustrated in printed editions of the poem (Slim 1985, pp. 250–51). The artist's replacement of the bagpipe by a recorder—an instrument associated with shepherds— conforms to musical practice and suggests that, to a much greater extent than Caravaggio's *Musicians* and the two versions of the Lute Player, this picture is based on an actual performance.

Marotta arrived in Rome from Sicily and began to work for Cardinal Gerolamo Mattei in 1600, dedicating his *Aminta musicale* to the cardinal in that year. Interestingly, in 1601 Caravaggio was living in the Mattei palace (Parks 1985, p. 441), and the *Saint John the Baptist in the Wilderness* (1601–1602; Pinacoteca Capitolina, Rome) he painted for Ciriaco Mattei was interpreted by two contemporaries as showing a shepherd, underscoring the popularity of pastoral themes. It is tempting to believe that *The Lament of Aminta* records an actual performance in the Mattei palace (Slim 1985, p. 251).

The composition enjoyed considerable popularity. Four versions of varying quality are known. The prime version, formerly in the Franco Piedimonte collection, Naples, and then with the Matthiesen Gallery, London, is shown here. Other versions are in the Louvre, in a private collection in Bergamo (Salerno 1984, p. 89, fig. 22.8), and in a private collection in Pennsylvania.

The ex–Piedimonte-Matthiesen picture has been variously attributed, but it is likely to be by Bartolomeo Cavarozzi, who worked primarily in Rome, where he was associated with the Crescenzi family and the

academy founded by the aristocratic amateur Giovanni Battista Crescenzi. According to Baglione, Crescenzi had students at the academy work from life ("far ritrarre dal naturale"), with a strong emphasis on still-life painting. Crescenzi sometimes wandered through Rome in search of fruits, animals, and "curious" objects as models (Baglione 1642, p. 365); he is reported to have painted still lifes himself, including one for the Spanish crown, and it has been suggested that he may have collaborated with Cavarozzi in compositions of this sort (see especially Volpe 1973, p. 32). The sumptuous grapes were, in any case, the sort of still-life objects Crescenzi favored (Baglione 1642, p. 343), and they are, together with the strong lighting, the most Caravaggesque elements in the picture. AB

Pietro Paolini

Lucca 1603–1681

13. THE CONCERT

1620–30
Oil on canvas; 100.5 × 133.5 cm. (39⅝ × 52½ in.)
Monogrammed: *PPL*
J. Paul Getty Museum, Malibu

THIS PICTURE WAS painted in the 1620s, during Paolini's decade-long sojourn in Rome, where, according to the seventeenth-century biographer Baldinucci (1773, p. 28), he studied with Angelo Caroselli, a somewhat disreputable follower of Caravaggio. A fascinating commentary on Caravaggio's *Musicians*, it demonstrates the broad impact Caravaggio's allegorical pictures had on later artists. The Lucchese artist must have seen Caravaggio's painting in the collection of Cardinal del Monte, and the general features of the composition and several of its details, such as the still life of the violin and open part-book with an upturned page, derive directly from Caravaggio's picture. However, instead of three androgynous youths in loose-fitting blouses, Paolini shows three women in distinctly contemporary dress, one of whom plays a cittern while the others play lutes. Their individualized physiognomies suggest portraits, and there can be little doubt that Paolini meant to suggest an actual performance. Trios of female musicians achieved considerable fame in this period, following the dazzling reputation established by Alfonso II d'Este's three virtuoso sopranos (Giustiniani ca. 1628, p. 22; Reese 1959, pp. 409–11). These women, however, were probably studio models rather than professional musicians; the dark-haired woman to the right resembles the figure of the Magdalen in another early work by Paolini in the Galleria Pallavicini, Rome (Giusti Maccari 1987, p. 74, cat. 1). The inclusion of Cupid, who replaces Caravaggio's self-portrait with a cornetto, demonstrates that here, as in *The Musicians*, an allegory of Love and Music is presented in the guise of an actual concert.

In the sixteenth century allegorical depictions of Music almost always consisted of three women, usually in classical robes, playing wind as well as stringed and sometimes keyboard instruments and accompanied by Cupid (Egan 1961, p. 193), "demonstrating that Love is born from Music, or really that Love is always in the company of Music" (Vasari 1568, VI, p. 373). Giustiniani (ca. 1628, p. 29), who accepted this connection implicitly, wondered why music "moved the soul to love," especially among women. In Paolini's painting the red carnation proffered by Cupid to one of the women is a pointed allusion to the relation of Love and Music (on the significance of the carnation, see Levi D'Ancona 1977, p. 80), and his gesture may also imply that these three women are offering their love to the viewer, an aspect of numerous sixteenth-century paintings with musical subjects. AB

14. BACCHIC CONCERT

About 1625–30

Oil on canvas; 122 × 183 cm. (48 × 72 in.)

Inscribed on sheet at left: *Mosse una . . . il mio cor Vago*

Dallas Museum of Art. Karl and Esther Hoblitzelle

Collection, Gift of the Hoblitzelle Foundation

ONE OF Paolini's most striking pictures, this *Bacchic Concert* was almost certainly painted in Rome, shortly before Paolini's departure for Venice and his final return to Lucca in 1631. Bacchus is shown playing a (fictitious) pipe and facing his singing followers; one of them reads from a sheet of music, another holds fruit and a flute, and a third, who plays the lute, glances out of the painting. An enigmatic woman at the left, her back turned toward the viewer and a cittern slung over her shoulder, studies a sheet of music. Although not yet identified, the lyrics seem to be a sonnet by Petrarch ("Per ch'al viso d'Amor"), which was set to music by numerous composers.

Paolini drew on two compositions by Caravaggio in Cardinal del Monte's collection, which he must have known firsthand. The woman at the far left derives from the figure at the right in *The Musicians* (Spear 1971, p. 136), and the crumpled drapery on which the lute rests may be inspired by the still life in the same work. The lutenist appears to be based on the Del Monte *Lute Player*, although the sex of the musician has been changed. The strong raking light which sculpts Bacchus's back, leaving his face and right hand in deep shadow and illuminating the garlanded singer at the center, also derives from Caravaggio. This dramatic chiaroscuro was recognized by his contemporaries as a salient quality of Paolini's mature style (Baldinucci 1773, p. 31).

Perhaps the most significant aspect of the *Bacchic Concert* is the juxtaposition of the ancient god Bacchus with figures in contemporary dress. Yet, this too is an elaboration of Caravaggio's *Musicians*, where a winged cupid, symbolizing the association of love, music, and wine, appears with the other figures. Here the god of wine—with a stupendous still life of grapevines in his hair that is also inspired by Caravaggio—leads the music-making. Paolini seems to have particularly enjoyed contrasting the real and the allegorical or mythological. Baldinucci (1773, p. 29) describes his picture of a concert where female musicians are shown with a putto and with a nude woman representing Luxury; another

early source records his painting of a "bald man playing the guitar, with an ugly woman to the right and an ugly cupid behind" (Giusti Maccari 1987, p. 76).

The combination of Bacchus with a contemporary proselyte is found slightly earlier in the work of Bartolomeo Manfredi (Merlo 1987, p. 60), and a painting by the Flemish Caravaggesque artist Theodoor Rombouts shows musicians in seventeenth-century dress with a bacchante (Mirimonde 1965a, p. 138). The northern followers of Caravaggio particularly influenced Paolini's work; many of his figures, such as the man who sings gustily with an open mouth, are directly related to their lowlife characters. By far the greatest Caravaggesque work mixing myth and actuality is Velázquez's *The Feast of Bacchus* (Museo del Prado, Madrid). Interestingly, Paolini's *Bacchic Concert* was at one time attributed to both Manfredi and Velázquez (Ottani 1965, pp. 182, 187).

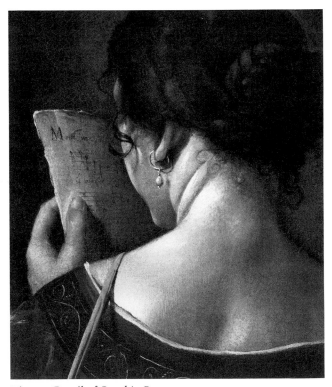

Fig. 40. Detail of *Bacchic Concert*.

It is possible that the woman with the garland of flowers and numerous jewels, including pearls, a beaded net, and gold chains through her hair, alludes to Vanity. She is almost identical to the young woman in Paolini's *Three Ages of Man* (private collection, Lucca; Giusti Maccari 1987, p. 88 cat. 10) who is shown removing her jewels and setting them within an arrangement of a vase of flowers, a mirror, and musical instruments. This scene has been interpreted as a vanitas piece (Marabottini Marabotti 1963, p. 310), and the theme may be present in the *Bacchic Concert* as well. The atmosphere of dissolution is heightened by several subtle motifs. Laurence Libin

notes that the lute seems intentionally portrayed with two broken strings and that the figure to the far right holds his flute in a provocative manner.

The figure of Bacchus may be based on the Ludovisi Mars, an ancient sculpture which was purchased by the Aldobrandini family in Rome in 1622 (Haskell and Penny 1981, cat. 58, see ill. 32). Paolini was interested in antiquity and assembled a substantial collection of objects, including antique coins and casts of classical statuary, upon his return to Tuscany in 1631. This was later made available to the students of the academy he opened in Lucca in 1640 (Giusti Maccari 1987, p. 19). AB

Orazio Gentileschi

Pisa 1563–London 1639

15. THE LUTE PLAYER

About 1610–15
Oil on canvas; 143.5 × 128.8 cm. (56½ × 50¾ in.)
National Gallery of Art, Washington, D.C.
Alisa Mellon Bruce Fund

ALTHOUGH DIVERGENT in many details, this marvelously poetic painting, which shows a young woman dressed simply in a white chemise with a yellow dress playing or tuning a lute, captures the mood of the Giustiniani-Leningrad *Lute Player* by Caravaggio (cat. 4). This similarity is not surprising, for Gentileschi was in close contact with Caravaggio by about 1600. The two shared studio props as well as ideas about painting, and although in September 1603 Caravaggio denied that they were still friends, his art continued to be of fundamental importance to Gentileschi, who adopted Caravaggio's practice of working directly from posed models and his use of strong, raking light.

Gentileschi treated the theme of women playing musical instruments several times. It has been suggested (Camiz 1985, p. 254) that his interest in musical subjects and particularly in depictions of Saint Cecilia, the patron saint of music, may have been stimulated by his membership in the Virtuosi del Panteon from about 1605. This was an academy for painters, but its seat was in the same location as the Congregazione dei Musici di Roma, which was under the patronage of Saint Cecilia. Gentileschi depicted Saint Cecilia playing a keyboard instrument assisted by a winged angel on at least two occasions: in a picture now in the National Gallery of Art, Washington, D.C., and in a variant composition of this work formerly in a Franciscan church in Todi and now in the Galleria Nazionale, Perugia (for objections to the status of the Perugia picture, see Bissell 1981, p. 167, cat. 37). Another, earlier painting of a young woman playing a violin (Detroit Institute of Arts) has been interpreted as showing Saint Cecilia (Bissell 1981, p. 156, cat. 28); it includes no specific attributes, however, and in the eighteenth century it was described simply as a "half-length figure of a woman who plays the violin" (Ratti 1780, p. 265).

When the present painting was sold in Bologna in 1697 to Prince Johann Adam von Liechtenstein through his agent Marc'Antonio Franceschini, it too was described as "a woman who plays, by Gentileschi" (Shapley 1979, I, p. 201), and it may be questioned whether the picture was meant to convey any more specific meaning. (The musical notation has been abraded, and pseudoletters are employed.) The beautiful young studio model may be a reference to Harmony, although she is not turning the pegs to tune her lute, or her pose may be intended as an allusion to the sense of hearing. On the other hand, the array of instruments—a violin, recorders (or a recorder and a flute), and a cornetto—and the two open scores may be intended, at least indirectly, as an allegory of Music, for which Ripa (1603, p. 345) recommends a "woman, who with both hands holds Apollo's lyre and at her feet has various musical instruments." The subjects of Gentileschi's paintings on musical themes were elusive even to his contemporaries. Joachim von Sandrart, who lived in Vincenzo Giustiniani's palace from 1629 to 1635, vaguely described Gentileschi's *Musical Concert with Apollo and the Muses*, frescoes in Palazzo Pallavicini Rospigliosi, as "musicians and other representations" (1675, p. 166). Indeed, what is striking in Gentileschi's work is the lack of insistence on any allegorical point. The poetry of *The Lute Player* resides not in its interpretation of an allegorical conceit, but in Gentileschi's transcription of a visual reality—down to the loosed lacing of the dress and the still, rapt expression of the model.

The picture dates from about 1610–15 when Caravaggio's influence was most strongly felt by Gentileschi. But the works by Caravaggio it recalls are not those closest to it in time but the pictures of his earlier years with Del Monte. The indeterminate and neutral space, illuminated by a diagonal shaft of light, and the exquisite attention to details of costume and texture are reminiscent of Caravaggio's *Magdalen* of about 1595 (Galleria Doria-Pamphilj, Rome), while the still life depends more or less directly on those in the two Lute Players. AB

Theodoor Rombouts

Antwerp 1597–1637

16. THE LUTE PLAYER

Oil on canvas; 111.3 × 99.7 cm. (43⅞ × 30¼ in.)
Signed with monogram on tankard: *TR*
John G. Johnson Collection, Philadelphia Museum
of Art

BORN AND TRAINED in Antwerp, Rombouts followed the example of numerous Flemish artists and moved to Rome, where a "Theodoro Rombado fiamengho" is mentioned in 1620 (Houtzager and Meijer 1952, p. XXXIII). Rombouts must have had considerable success there, as he was summoned by Grand Duke Ferdinando I de'Medici to work in Florence (Schneider 1966, unpaginated). Most of his later career was spent as a highly respected painter in Antwerp, where he had many students.

Rombouts arrived in Rome after Caravaggio's death, but he apparently saw Caravaggio's paintings not only in churches but also in private collections which were open to interested visitors. The composition of this picture, as well as many of his other paintings of musicians, strongly suggests that he knew the Del Monte *Lute Player* (cat. 5). The similarities between the two images are striking: in each a musician holding a lute is shown seated behind a table covered with a carpet, with sheet music before him. Here, however, the musician wears a showy, theatrical costume rather than the vaguely classical dress of Caravaggio's singer, which suggests a refined environment. This change is in keeping with works depicting musicians by Rombouts's contemporaries in the north, such as Baburen's *Lute Player* in Utrecht. These figures in their plumed hats and elaborate jackets are contemporary street performers, as is made clear by Rombouts's extraordinary life-size *Musicians* (Spencer Museum of Art, Lawrence, Kansas; fig. 36) in which a guitarist and a female singer perform on a platform before a raised curtain.

Rombouts's lutenist is shown tuning his instrument. The accuracy with which the musician manipulates the lute is noteworthy, especially the description of the right hand, with the little finger used as a pivot, the thumb for single notes, and the other fingers for chords. Humorous mention was often made of the amount of time lute players devoted to this task: "someone claimed that the eighty-year-old lutenist spent more than sixty of them tuning his lute" (Mirimonde 1965a, p. 132).

There may also be an allegorical meaning behind the activity. Medieval allegories of Music often depict a woman tuning an instrument, suggesting the attaining of harmony by bringing the strings to the correct intervals (Egan 1961, p. 185). This is almost certainly the meaning of the action in Laurent de la Hire's *Allegory of Music* (cat. 19). Van Mander (1617, I, pp. 124–25), in writing about a print by Lucas van Leyden in which instruments are tuned, suggests familial harmony as the theme, and indeed this is an idea with classical roots. The sitter's furrowed brow and glaring look seem to underscore the difficulty of the task.

Walter Liedtke has suggested that the conspicuous alignment of the tuning pegs, tankard, and pipe, along with the stern glance of the musician, may be an admonition to practice temperance (for stringed instruments as symbols of temperance, see van Thiel 1967–68, pp. 91–92). The still life also suggests the fleeting pleasures of smoking and drinking and alludes to the *vita voluptuosa* which ends with death (Fischer 1972, p. 91). The pipe in particular was linked with music in that the moment of pleasure is so evanescent. These common northern symbols are an addition by Rombouts to Caravaggio's scheme, which had its own vanitas overtones.

Rombouts's paintings are difficult to date, especially as works from his Italian period are almost completely undocumented. This work, with its dramatic Caravaggesque lighting, is probably early. Even so, Rombouts has already abandoned the elevated quality of Caravaggio's *Lute Player* for a coarser image, one that suggests a lowlife setting and reinforces its primary meaning as genre. There are at least three other versions of this popular composition (Antwerp, Paris, Dunkerque), of which the Philadelphia painting is the finest (Hoog 1960, p. 274; Mirimonde 1963, pp. 167–68). AB

Evaristo Baschenis

Bergamo 1617–1677

17. STILL LIFE OF MUSICAL INSTRUMENTS AND A GLOBE

About 1660
Oil on canvas; 106 × 150 cm. (41¾ × 59 in.)
Signed on back of lute: *Evaristus Baschenis F.*
Private collection

ALTHOUGH EVARISTO BASCHENIS painted a number of kitchen scenes, he is best known as the creator of still lifes of musical instruments. Indeed, such pictures were later called Bergamasque, after the city of his birth, no matter who the artist. This painting, which dates fairly late in his career, includes an assortment of instruments—a shawm, a violin, two bows, two lutes, a recorder, and what may be a five-stringed tenor violin—as well as sheets of paper, books, a celestial globe, an astrolabe, and an elegant *scrigno* (cabinet). It thus conforms to the description given by F. M. Tassi (1793, p. 234), the most important source for painting in Bergamo, of the artist's most intricate compositions.

The origins of this type of still life are complex and not altogether clear, but Caravaggio is probably a major source, both visually and theoretically. Baschenis would have been interested in Caravaggio, whose hometown was near Bergamo. Little is known of Baschenis's movements, but he was a priest, and it is not unlikely that he visited Rome. There he could have seen Caravaggio's *Amor vincit omnia*, with its still life of instruments and sheet music (Salerno 1984, p. 153), and both versions of *The Lute Player*. Given the appearance of his later works, the geometric arrangement and tactile rendering of the instruments in the Del Monte *Lute Player* must have impressed him. The attention Caravaggio lavished on the still-life details in these works exemplifies his reported belief that it required "as much effort to make a good painting of flowers as of figures" (Giustiniani ca. 1620, p. 42). This elevation of still-life painting, combined with the fact that Caravaggio's *Basket of Fruit* was in Milan, may have been decisive in sparking Baschenis's interest in the genre.

Two other linked sources for the content of the musical still life have been cited: illustrated perspective manuals and intarsia panels. The depiction of the lute

was a major preoccupation in perspective treatises from the early sixteenth century, and writers stressed the ingenuity needed to portray difficult shapes such as the lute: "It is held a most difficult thing to put into foreshortening regular bodies and above all those composed of curved lines such as the viola and the lute" (Sirigatti 1596 in Rosci 1971, p. 34). These lessons in perspective were put into practice in intarsia panels (one of the most famous specialists in this field, Fra Damiano Zambelli, was Bergamasque). Baschenis's paintings combine this delight in achieving such difficult representations with a deeper understanding of the beauty of still life as alluded to by Caravaggio. Tassi remarked that his arrangements are striking for their "incredible naturalness and truth" (1793 in Spike 1983, p. 71).

The still life in the Giustiniani-Leningrad *Lute Player* by Caravaggio seems to allude to the theme of vanitas, as does Baschenis's work. In the latter's paintings a piece of fruit or—more unusually— streaks of dust across the instruments' backs underscore this theme (Eccles. 3.20: "All are from the dust, and all turn to dust again"). In this painting there is a globe, which frequently appears as a symbolic object in more explicit vanitas paintings, examples of which were in Bergamo during Baschenis's lifetime (Rosci 1971, p. 19, ill. IV). Spike (1983, p. 72) has noted that most scenes of musical instruments have an inherent vanitas significance since "the sweetest sound soon falls silent." That Baschenis's pictures were understood in this way is demonstrated by the northern artist Cornelis van der Meulen, who painted a still life in direct emulation of Baschenis, adding an hourglass suspended on the wall (Bergström 1971, pl. 32). A contemporary northern print of a musical still life by Theodor Matham includes the inscription *Vanitas* with a skull, an explicit reference to the association of music and transience (Fischer 1972, p. 87). AB

Andrea Sacchi

Rome 1599–1661

18. MARC'ANTONIO PASQUALINI CROWNED BY APOLLO

About 1640
Oil on canvas; 243.8 × 194.3 cm. (96 × 76½ in.)
The Metropolitan Museum of Art. Purchase, Enid
A. Haupt Gift, Gwynne Andrews Fund, and
Purchase, 1871, by exchange, 1981 1981.317

MARC'ANTONIO PASQUALINI (1614–1691) was per- haps the leading male soprano (castrato) of his day and was also a composer. Following his training at the French national church of San Luigi dei Francesi in Rome, he came to the attention of Antonio Barberini, who is cited as the singer's protector upon his entry into the Sistine Choir in 1631. During the following decade he starred in most of the operas staged by the Barberini in their palace, establishing a reputation for vocal bril- liance as well as arrogance (on his career, see especially Cametti 1921). Like earlier male sopranos—including, presumably, Pedro Montoya, Cardinal del Monte's resi- dent castrato—Pasqualini also performed at private gath- erings (his personal collection of musical manuscripts included works for the solo voice over a basso continuo; see Murata 1980, p. 131). Indeed, in 1640 Elpidio Benedetti reported to Cardinal Mazarin that he had entertained some gentlemen (including Paul Fréart de Chantelou, who had been sent to Rome to accompany Poussin to Paris) who had "great knowledge of painting, sculpture and architecture.... I invited them to come and taste an Italian meal in my house, where I thought to have them hear some outstanding virtuosi, and especially Marc'Antonio Pasqualini, whose virtues are held in high esteem" (Murata 1980, p. 128).

Sacchi's portrait of Pasqualini dates from about 1640, following the singer's appearance in *La Pazzia d'Orlando* in 1638 and the revival performance of the five-hour *Chi soffre speri*, with *intermedi* designed by Bernini (Hammond 1979, pp. 112–20). The date of the picture is established by studies for the figure of Apollo on the recto of a sheet with preparatory drawings for Sacchi's canvas of the 1639 celebrations at Il Gesù, for which he was paid in November 1641 (see Camiz 1988, p. 185

n. 49). The earliest description of the work is by Bellori (1672–96, p. 568), who observed:

> Andrea [Sacchi] applied his greatest industry in the portrait of Marc'Antonio Pasqualini, a famous so- prano in his day and a close friend in the court of Cardinal Antonio Barberini. This is not a simple portrait but a most beautiful conceit, [Sacchi] hav- ing shown [Pasqualini] in the costume of a shepherd with Apollo who crowns him. He places his hands on a spinet, or rather an *arpicembalo* with keys, and the cords upright in the guise of a harp, and while playing he turns to display his face, most beauti- fully painted from life.... Opposite is shown Apollo, who with one hand places the crown of laurels on [the singer's] head and with the other holds a lyre at his side. On the ground lies a bound satyr, to signify his competition and punishment.

As in Caravaggio's *Musicians*, Sacchi's portrait com- bines features of contemporary musical practice with allegory to produce a picture that can be read on several levels (see Christiansen 1982; Ford 1984; Camiz 1988). The resemblance of the composition to Poussin's virtu- ally contemporary design for a frontispiece for a book on Virgil in which Apollo crowns the Roman poet has been noted (Camiz 1988, p. 182). However, Bellori understood Pasqualini's costume— similar to those Caravaggio depicts—to be that of a shepherd, and a comparison with those worn by the figures performing a ballet of shepherds and nymphs in the Falconieri palace in 1634 (fig. 34) bears this out. The costume doubtless evoked one of Pasqualini's roles in addition to referring to the bound figure of Marsyas. The instru- ment he plays is a rare type of clavicytherium, or keyed

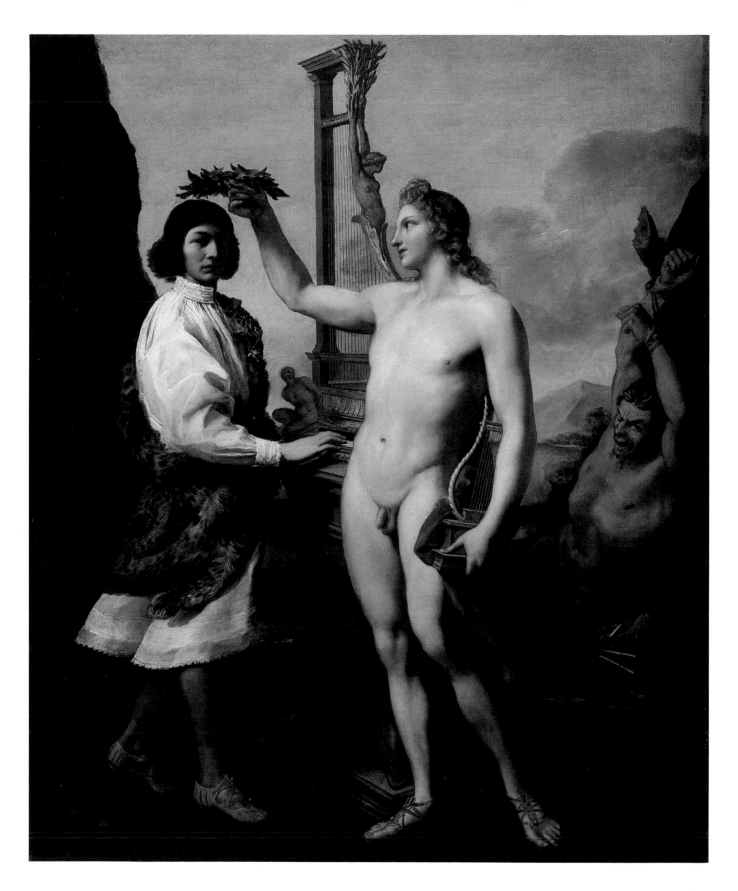

harp, that gave a delicate, sweet sound suitable to chamber performances (see Van der Meer 1978; Ford 1984, pp. 82–83). One such instrument is listed in the Barberini inventories (Lavin 1975, p. 156), and Sacchi may, in fact, show a specific clavicytherium on which Pasqualini performed. Similarly, the table, supported by three dolphins reminiscent of Bernini's Triton Fountain outside Palazzo Barberini, may have existed. It is a solo performance such as Pasqualini had so often given that Apollo awards, but one elevated to a mythic status by its contrast to Marsyas's punishment for his bold and unsuccessful challenge to a musical contest on his rustic pipes (here shown as bagpipes such as a real shepherd might use). To an even greater degree than the paintings by Caravaggio and Cavarozzi, this picture admits the viewer into the world of late Renaissance–early Baroque musical practice. Himself a musician, Sacchi was a close friend of Pasqualini and designed some of the stage sets and props for his performances.

No similarly elaborate portrait of a castrato is known prior to Corrado Giaquinto's and Jacopo Amigoni's depictions of the celebrated eighteenth-century singer Farinelli, and considerable interest attaches to the identity of the person who commissioned it. Any member of the Barberini family may be excluded, since there is no record of a payment for it in their account books and no mention of it in their inventories (the picture is first listed in the collection of the Marchese Niccolò Pallavicini in 1700). Giulio Rospigliosi, who wrote a number of the libretti for Barberini operas, has been suggested as a candidate (Sutherland Harris 1977, p. 83), but this cannot be demonstrated; the most probable candidate is Pasqualini himself, whose friendship with Sacchi and vain character accord perfectly with the self-adulation implicit in the imagery (see Camiz 1988, p. 183). Indeed it now appears that in the seventeenth century musicians emerged not only as outstanding personalities but also as significant patrons: the composer and harpist Marco Marazzoli commissioned an ambitious allegory of Music from Lanfranco that he later gave to Antonio Barberini (Camiz 1988, p. 183). KC

Laurent de la Hire

Paris 1606–1656

19. ALLEGORY OF MUSIC

Oil on canvas; 94 × 136.5 cm. (37 × 53¾ in.)
Signed and dated lower left: *De La Hire,/P. 1649*
The Metropolitan Museum of Art. Charles B. Curtis Fund, 1950 50.189

ACCORDING TO his son Philippe, La Hire painted several canvases representing the Seven Liberal Arts for a room in the house of a Monsieur Tallemant in the Marais section of Paris (1690; see Mariette 1854–56, p. 48); this magnificent ensemble seems to have been replicated for another patron in Rouen (Dézallier d'Argenville 1762, p. 66). The present painting is the finest of the extant portions of the Tallemant commission (for a reconstruction of the series, see Rosenberg and Thuillier 1988, pp. 292–94). The allegorical figures, dated 1649 and 1650, were presumably separated by classical moldings. There were additionally narrow canvases of putti, of which only those that originally flanked the *Allegory of Music* are known (Musée Magnin, Dijon); these extend the architectural background of the central image and complement its iconography.

Music is personified by a statuesque young woman who wears loose classical robes and tunes a large angelica or single-stringed chitarrone. On, or leaning against, a table are a lute, a violin, two flageolets, a shawm, and an open part-book plus a sheet of flageolet tablature; behind the figure there is a carved organ case. One of the putti in the companion canvas at Dijon plays a viola da gamba, while the other sings from a sheet of music.

In these allegories La Hire adhered quite closely to the descriptions formulated by Cesare Ripa in his *Iconologia*, first printed in 1593 but revised over the years and translated into French by Jean Baudouin (Paris, 1644). For example, the *Allegory of Grammar* (National Gallery, London) follows Ripa's recommendation of a young woman watering flowers with her right hand, alluding to the care with which "seedlings" (whether floral or human) must be nurtured, while holding in her left a long banderole with an inscription proclaiming the importance of speaking correctly. The *Allegory of Music* does not reproduce Ripa's prescriptions so literally.

Rather than showing a woman writing music, with instruments at her feet, it shows her tuning the angelica. Both, however, stress the harmony that is created as the strings are tuned or the instruments blend with each other and the voice. This combination is emphasized by Ripa, whose entire description of harmony revolves around music. Other details are taken directly from Ripa's entry on music, particularly the nightingale, "a true symbol of music, for the marvellous effects of its voice which charms those who listen to it."

A sociable man, La Hire was a good singer and loved music "extrêmement" (Guillet de Saint-Georges ca. 1691, in 1854, p. 114). Gédéon Tallement, a member of the Council of State, is known to us through the writings of his cousin, Tallemant des Réaux, who included a portrait of him in his *Historiettes* (1961, II, pp. 545–47). Des Réaux was rather disapproving of Tallemant, complaining that his house was in a "dreadful quarter" of Paris but admitting that he had "magnificent furnishings." Above all, Tallemant is described as a man of pleasure, given to collecting, gambling, drinking, and women. These pastimes are wittily referred to in the music held by the singing putto in the companion canvas. The text of this is a 1647 drinking song by Guillaume Michel, a minor composer whom Tallemant probably knew (Michel also held a government post as *audiencier* in Mazarin's entourage; Mirimonde 1975, pp. 22–23). The song describes a contest between Bacchus and Eros, Wine and Love, in which Love has lost. The last legible lines read: "Je beniray le jour/Que les jus de la pinte/A noyé mon amour..." (I bless the day that the juice of the pint drowned my love). The reference to Wine and Love not only alluded to Tallemant's escapades but also completed the triad often brought together by Ripa and other writers: Music, Love, and Wine—elements found also in Caravaggio's *Musicians*, which La Hire knew firsthand.

Three separate pieces are illustrated in the music book before the female figure. Laurence Libin has noted that the first is a series of phrases used as practice in the singing of intervals; the second, a lute tablature using a tuning devised by Denis Gaultier about 1635; and the third, a chanson in two parts. The last has not been identified, but it too may be a song by Michel (Greenwald 1987, p. 8). This combination probably alludes to the threefold division of music into theoretical (the solfeggio exercises), instrumental, and vocal. AB

German, 17th century
(with later additions)

20. TENOR SHAWM
Maple body length 109.3 cm. (43 in.)
The Metropolitan Museum of Art. The Crosby Brown Collection of Musical Instruments, 1889 89.4.2625

ONCE THOUGHT to be entirely a reproduction of a Baroque instrument preserved in Middelburg, Netherlands, this tenor shawm is now believed to incorporate a rare original body section; the bell, brass crook, and perforated, brass-ringed fontanelle that covers the single brass key are later. In La Hire's *Allegory of Music* (cat. 19), the top portion of a similar shawm is shown leaning against a table, partly supporting an open music book. Unfortunately its double reed is indistinct. Members of the loud (*haut*) Renaissance wind band much used for ceremonial and dance music, shawms of various sizes were gradually replaced by more refined woodwinds, the oboe (*hautbois*) and bassoon, which are better suited to playing indoors. After about 1670 an instrument such as this shawm would have been outmoded at the French court, where the oboe was earlier invented, possibly by Jean Hotteterre, a member of the Grande Écurie du Roi. But the shawm's form would have been familiar to La Hire's contemporaries and immediately recognizable even from the small bit revealed in his painting. It can be distinguished from a bass recorder, with which it has been confused by some modern writers, by the absence of a "mouth" near the top of the wooden tube. The crook is curved to keep the finger holes within reach; even so, a key was needed to govern the lowest hole. Its swallowtail touchpiece can be operated by either the left or right hand. LL

German, 17th century

21. FLAGEOLET

Ivory; length 16.2 cm. (6⅜ in.)
Stamped: *M*
The Metropolitan Museum of Art. The Crosby Brown
Collection of Musical Instruments, 1889 89.4.915

T HE TERM "flageolet," which originally referred to a variety of flutes, came to be associated during the Renaissance with ducted types having fewer finger holes than the recorder. In his treatise *Harmonie universelle* (1636–37), the French scientist and music theorist Marin Mersenne mistakenly credited the flageolet's invention to the Sieur de Juvigny about 1581. De Juvigny, a member of the Balet comique de la Royne, may have developed a novel flageolet with tapered bore, four finger holes, and two thumb holes; this type became standard and is represented in La Hire's *Allegory of Music* (cat. 19), lying on a manuscript sheet of flageolet tablature; the bell of a second, smaller flageolet protrudes from beneath the large music book. La Hire's flageolets may form an iconographic link between the natural and artificial musics represented respectively by the nightingale and the notated scores. Short flageolets, sounding at high pitch, were employed during the Baroque era to teach popular tunes to singing birds that mimic melodies they have heard. The finely turned ivory flageolet shown here is such an instrument; too delicate to be of much use in concerted music, it may have been played just for fun or for the edification of a finch.

LL

David Tecchler

Augsburg about 1666–Rome after 1747

22. CHITARRONE

1725
Ebony, spruce, tortoiseshell; length 179.7 cm.
(78¾ in.)
Signed: *Dav: Tecchler fecit Roma AD 1725*
The Metropolitan Museum of Art. Purchase, Clara
Mertens Bequest, in memory of André Mertens,
1988 1988.87

THE INVENTION of the chitarrone (large kithara) has
been attributed to Antonio Naldi, lutenist at the
Medici court in Florence, where the instrument is first
mentioned in accounts of theatrical performances in
1589. This variety of lute, having an extended neck
bearing unfretted bass strings, represents an attempt by
Florentine poets and musicians to imitate ancient Greek
musical practice. The same humanistic impulse gave rise
to a new declamatory style of vocal writing, from which
opera emerged. The chitarrone was a favorite instrument
for accompanying singers throughout the seventeenth
century but had begun to fall from fashion when this late
example was made by the most prominent luthier then
active in Rome. Tecchler's bowed instruments, espe-
cially cellos, are highly regarded by performers today;
this is his only known extant chitarrone. A similar large
lute strung with single rather than double courses was
known as an angelica or angelique; it is one of these, with
six treble strings and seven bass strings, that La Hire
depicts being tuned in his *Allegory of Music* (cat. 19),
where the act of tuning represents the birth of concord.
Note in that picture the extra length of gut string hanging
from the lowermost tuning peg; if the stretched string
broke, the extra length could have been used to knot it.
La Hire painstakingly distinguishes the thicker bass
strings from the thinner treble ones, but his equidistant
placement of frets on the fingerboard is unrealistic.

LL

Antonio Stradivari

Cremona 1644–1737

23. VIOLIN

1693
Spruce and maple; overall length 59.1 cm. (23 ¼ in.)
Labeled: *Antonius Stradivarius Cremonensis Faciebat Anno 1693*
The Metropolitan Museum of Art. Gift of George Gould, 1955 55.86

WHILE IT HAS NOT been conclusively proved that Stradivari was a pupil of Nicolò Amati, as has often been stated, the early influence of Amati's designs on Stradivari is clear. The striking tonal difference between these masters' violins arises from alterations that Stradivari made in the proportions of the body, notably in flattening the arch of top and back in order to produce a stronger sound. Although not widely appreciated during his lifetime, Stradivari's powerful violins were favored by many later virtuosi; as a result, his instruments were modified to suit post-Baroque performance styles. Of about six hundred extant "Strads," only this fine "long pattern" example has been restored to a close approximation of its original configuration and now produces the kind of sound that Stradivari himself had in mind. Fortunately, many of his templates survive to guide the modern restorer, and much has recently been learned about pitch and strings of his period. Use of an appropriate bow is crucial to proper tone production, phrasing, and articulation; Baroque bow sticks, often represented in paintings, are straight or slightly convex rather than concave as became normal in the late eighteenth century and tend to be shorter than later bows.

LL

BON TEMPS

Fig. 41. Pierre Brebiette, *Bon Temps*. The Metropolitan Museum of Art.

Checklist of Prints and Printed Books

Unless otherwise stated, all of the following are in the collections of The Metropolitan Museum of Art.

Marcantonio Raimondi
Italian, 1475/80–1527/34
Portrait of Giovanni Filoteo Achillini, called il Filoteo
Engraving, ca. 1504–1505
(Delaborde 1888, cat. 232)
Harris Brisbane Dick Fund, 1925 25.2.26

Giovanni Paolo Cimerlini
Italian, active ca. 1568
The Snares of Death
Etching and engraving
(Martineau and Hope 1984, cat. P.55)
Harris Brisbane Dick Fund, 1931 31.75.24

Theodor Matham
Netherlandish, 1605/6–1676
Vanitas
Engraving, 1622
(Hollstein 1955, XI.253.36)
The Elisha Whittelsey Collection, The Elisha Whittelsey Fund, 1951 51.501.6107

Crispin de Passe I (after Martin de Vos)
Netherlandish, ca. 1565–1637
Adolescentia Amori (from *The Four Ages of Man*)
Engraving, 1596
(Hollstein 1964, XV.188.488)
The Elisha Whittelsey Collection, The Elisha Whittelsey Fund, 1949 49.95.2029

Raphael Sadeler I (after Martin de Vos)
Netherlandish, 1560–1628/32
Amor (from *The Four Ages of Man*)
Engraving, 1591
(Hollstein 1980, XXI.255.206)
Harris Brisbane Dick Fund, 1944 44.62.3

Pierre Brebiette
French, ca. 1598–1650
Bon Temps
Etching
(Weigert 1951–54, II.135.225)
Gift of Georgiana W. Sargent, in memory of John Osborne Sargent, 1924
24.63.1116 (61)
(See fig. 41.)

Pieter de Jode I (after Adam van Noort)
Netherlandish, 1570–1634
Concert
Engraving
(Nagler 1841, X.263)
The Elisha Whittelsey Collection, The Elisha Whittelsey Fund, 1959 59.570.193

Attributed to Crispin de Passe I
Netherlandish, ca. 1565–1637
Matin (from *The Four Parts of Day*)
Engraving
(Hollstein 1974, XVI.80.295)
Gift of Georgiana W. Sargent, in memory of John Osborne Sargent, 1924
24.63.491

Cornelis Cort (after Frans Floris)
Netherlandish, 1533–1578
Music (pl. 5 from *The Liberal Arts*)
Engraving, 1565
(Bierens de Haan 1948, 228, first state)
Harris Brisbane Dick Fund, 1928
28.4 (52)
(See fig. 42.)

Jacques Callot
French, 1592–1635
The Bohemians: The Rear Guard; The Vanguard; The Stopping Place; and *The Feast of the Bohemians* (series of four)
Etching and engraving
(Lieure 1929, 374–77, second state)
Rogers Fund, 1922 22.67.48–51

Jacques Callot
French, 1592–1635
The Prodigal Son
Etching and engraving
(Lieure 1929, 596, second state)
Harris Brisbane Dick Fund, 1925 25.2.4

Jacques Callot
French, 1592–1635
Balli di Sfessania (from a series of 24 plates)
Etching, 1621
(Lieure 1929, 379–402, first state)
Bequest of Edwin De T. Bechtel, 1957
57.650.304 (1, 3–10, 12, 14–17, 19–21, 23)

François Collignon (after Andrea Sacchi)
French, 1626–1671
Ballet in Casa Falconieri (from the *Festa fatta in Roma, alli 25 di febraio, MDCXXXIV*)
Etching, Rome, 1649 (first ed. 1635)
(Weigert 1951–54, III.113.47)
Harris Brisbane Dick Fund, 1930
30.58.5 (91–103)
(See fig. 34.)

Claude Mellan (after Nicolas Poussin)
French, 1598–1688
Apollo Crowning Virgil (title page for *Publii Virgilii Maronis*)
Engraving, Paris, 1641
(Préaud 1988, 209.358; Montaiglon 1856, 303, first state)
Harris Brisbane Dick Fund, 1941 41.57.29

Torquato Tasso
Italian, 1544–1595
Aminta, favola boschereccia del Sig. Torquato Tasso
Aldus Manutius, Venice, 1590
Harris Brisbane Dick Fund, 1937 37.37.19

Jacques Arcadelt
Flemish, ca. 1505–1565
Il primo libro di madrigali d'Archadelt a quattro voci con nuova gionta
Antonio Gardane, Venice, 1545
Special Collections Department, University of Utah Library

Appendix: Texts of Madrigals in Paintings

Caravaggio: *The Lute Player* (cat. 4)

Chi potrà dir
Chi potrà dir quanta dolcezza prova
Di madonn'amirar la luce altera
Che fa vergogn'a la celeste sfera?
Io non, chè 'n me non trovo
Lo stil ch'a lei s'aviene,
Che mirand'il bel volto e i bei costumi
Per non veder men bene,
Vorria perder'a un'hor la vit'e i lumi.

Who can express what sweetness I taste
In gazing on that proud light of my lady
That shames the celestial sphere?
Not I, who am unable to find within myself
The proper words,
So that, looking on her beautiful face and mien,
So as not to see less well
I would deign to lose together both life and light.

Se la dura durezza
Se la dura durezza
in la mia donna dura
Ahi! dura sorte mia, se durar deggio,
Amor la sua bellezza,
Chè, se per sempre veggio
Chiudermi 'l passo di pietà, qual sia
Pena ch'aguagl'in part'a questa mia?
Ma serà ben assai lieta mia sorte,
Se per sì gran bellezza giungo a morte.

If the obdurate obstinacy
of my lady endures,
O cruel fate!
If I must endure, O Love, her beauty
And ever see pity denied:
What shall equal even a portion of my pain?
But my fate shall truly be happy
If for so great a beauty I die.

Voi sapete
Voi sapete ch'io v'amo, anzi v'adoro,
Ma non sapete già che per voi moro.
Chè, se certo il sapeste,
Forse di me qualche pietate avreste.
Ma se per mia ventura
Talhor ponete cura
Qual stratio fa di me l'ardente foco,
Consumar mi vedret'a poco a poco.

You know that I love you, nay, I adore you.
But you do not yet know that I die for you.
Or, if you did
Perhaps you would show some pity.
But if by fortune
You should take note of
These wounds caused by my ardent fire
You will see me consumed by and by.

Vostra fui
Vostra fui e sarò mentre ch'io viva,
Faccia 'l ciel ciò che vuole,
Il viver mio così da voi deriva,
Come derivar suole
Ogni ben ch'è fra noi dal chiaro sole.
Dunque credete ch'io
Non vi posi nè mai porrò in oblio.

I was ever yours and so shall be while I have life,
Heaven bring what it may;
So greatly does my life depend from you,
As indeed
All that is good between us derives from the bright sun.
Therefore believe me
That I have never nor ever shall forget you.

Caravaggio: *The Lute Player* (cat. 5)

Lassare il velo o per sole o per ombra,
Donna, non vi vid'io,
Poi che in me conosceste il gran desio
Ch'ogni altra voglia d'entr'al cor mi sgombra.

I never saw you in the sun or shade,
Lady, remove your veil
After you knew the wish that makes me pale,
By which all other wills from my heart fade.

Mentr'io portava i be' pensier celati,
C'hanno la mente desiando morta,
Vidivi di pietate ornare il vólto;
Ma poi ch'Amor di me vi fece accorta,
Fuor i biondi capelli allor velati
E l'amoroso sguardo in sé raccolto.
Quel ch'i' più desiava in voi m'è tolto;
Sì mi governa il velo,
Che per mia morte, et al caldo et al gielo,
De' be' vostr'occhi il dolce lume adombra.

(Petrarch, sonnet 11)

While I was hiding the fair thoughts I bore,
That have undone my mind in this desire,
I saw compassion shine upon your face;
But when Love made you conscious of my fire
The blond hair became veiled and was no more,
The loving look closed in itself its grace.
What I most longed for finds its hiding-place
In you; the veil rules me,
Which to my death, hot or cold though it be,
Covers your eyes' sweet light as with a shade.

(Trans. Anna Maria Armi, 1946)

Perchè non date voi
Perchè non date voi,
Donna crudele fede a tanti sospiri
E perchè siete tanto acerbo e dura,
Che del'altrui martiri, godete?
Ahi lasso e del'altrui querele,
Non cognoscete voi che morte fura
Del corpo infermo
Ogni spirito vitale, secondo che di me dar
Vi posso io dare del mio soverchio ardore.

Why do you not believe,
O cruel lady, these many sighs,
And why are you so merciless and hard
That you enjoy the martyrdom of others?
Alas, you don't understand from another's lament
That death robs of an infirm body
Every vital spirit;
However much I can give,
I will give you of my abundant love.

Cavarozzi: *The Lament of Aminta* (cat. 12)

Dolor, che sì mi crucii,
che non m'uccidi omai? tu sei pur lento!
Forse lasci l'officio a la mia mano,
Io son, io son contento
ch'ella prenda tal cura,
poi che tu la ricusi, o che non puoi,
Ohimè, se nulla manca
a la certezza omai,
e nulla manca al colmo
de la miseria mia,
che bado? che più aspetto? O Dafne, O Dafne,
a questo amaro fin tu mi salvesti,
a questo fine amaro?
Bello e dolce morir fu certo allora
che uccidere io mi volsi.
Tu me'l negasti, e 'l Ciel, a cui parea
ch'io precorressi col morir la noia
ch'apprestata m'avea.
Or che fatt'ha l'estremo
de la sua crudeltate,
ben soffrirà ch'io moia,
e tu soffrir lo déi.

(From Torquato Tasso, *Aminta*, 3.2, ll. 1417–38)

O Grief, who torturest me so,
Why dost thou not slay me at the last? Thou art indeed slow.
Perhaps thou dost leave the deed to my own hand.
I am, I am content
That it should take the office
Since thou dost refuse it or since thou
Hast not the power.
O, alas, if naught is now lacking
To certainty
And if naught is wanting to the crown
Of my misery,
For what do I care? What more do I await? O Dafne, O Dafne,
To this bitter end hast thou saved me,
To this bitter end?
Surely it would have been fair and sweet to die
Then when I wished to kill myself.
Thou didst deny me that, and likewise Heaven
Whom I would have forestalled
By the death for which my weariness
Had prepared me. But now that it has
Compassed the extreme
Of its cruelty,
It will certainly permit me to die,
And thou must suffer it.

(Trans. Louis E. Lord, 1931)

Bibliography

Annibaldi, C. 1988. "Il mecenante 'politico': Ancora sul patronato musicale del cardinale Pietro Aldobrandini (1571–1621)." *Studi musicali* 17, pp. 101–78.

Baglione, G. B. 1642 [1935]. *Le vite de' pittori scultori et architetti, dal Pontificato di Gregorio XIII del 1572; in fino a' tempi di Papa Urbano Ottavo nel 1642*. Edited by V. Mariani. Rome.

Baldinucci, F. 1773. *Delle notizie de' professori del disegno da Cimabue in qua*. Vol. 17. Florence.

Barocchi, P. 1961. *Trattati d'arte del cinquecento*. Bari.

Bauch, K. 1956. "Zur Ikonographie von Caravaggios Frühwerken." In W. Braunfels, ed., *Kunstgeschichtliche Studien für Hans Kauffmann*, pp. 252–61. Berlin.

Bellori, G. P. 1672. *Le vite de' pittori, scultori e architetti moderni*. Rome.

———. 1672–96 [1976]. *Le vite de' pittori, scultori e architetti moderni*. Edited by E. Borea. Turin.

Bergström, I. 1971. *La natura in posa*. Vol. 2. Exhib. cat., Galleria Lorenzelli, Bergamo.

Berra, G. 1989. "Contributo per la datazione della 'Natura Morte di Pesche' di Ambrogio Figino." *Paragone* 40, no. 469, pp 3–13.

Bierens de Haan, J. C. J. 1948. *L'Oeuvre gravé de Cornelis Cort, graveur hollandais*. The Hague.

Bissell, R. W. 1981. *Orazio Gentileschi and the Poetic Tradition in Caravaggesque Painting*. University Park, Pa., and London.

Bologna, F. 1987. "Alla ricerca del vero 'San Francesco in estasi' di Michel Agnolo da Caravaggio per il Cardinale Francesco Maria del Monte." *Artibus et Historiae* 16, pp. 159–77.

Boyer, J.-C., and I. Volf. 1988. "Rome à Paris: Les Tableaux du maréchal de Créquy (1638)." *Revue de l'art* 79, pp. 22–41.

Bridgman, N. 1956. "Giovanni Camillo Maffei et sa lettre sur le chant." *Revue de musicologie* 38, pp. 3–34.

Calvesi, M. 1985. "La realtà del Caravaggio: Seconda parte (i dipinti)." *Storia dell'arte* 55, pp. 227–87.

Cametti, A. 1921. "Musicisti celebri del seicento in Roma: Marc'Antonio Pasqualini." *Musica d'oggi* 3, pp. 69–71, 97–99.

Camiz, F. T. 1983. "Due quadri musicali di scuola caravaggesca." *Musica e filologia*, pp. 99–105.

———. 1985. In *Cinque secoli di stampa musicale in Europa*. Exhib. cat., Palazzo Venezia, Rome. Naples.

———. 1988. "The Castrato Singer: From Informal to Formal Portraiture." *Artibus et historiae* 18, pp. 171–86.

———. 1989. "La 'Musica' nei dipinti di Caravaggio." *Quaderni di Palazzo Venezia*, no. 6, pp. 151–76.

Camiz, F. T., and A. Ziino. 1983. "Caravaggio: Aspetti musicali e committenza." *Studi musicali* 12, pp. 67–83.

Castiglione, G. B. 1528 [1967]. *The Book of the Courtier*. Translated by G. Bull. Harmondsworth.

Cavicchi, A. 1971. "La scenografia dell'*Aminta* nella tradizione scenografica pastorale ferrarese del secolo XVI." In M. T. Muraro, ed., *Studi sul teatro veneto fra rinascimento ed età barocca*, pp. 53–72. Florence.

Chater, J. 1987. "Musical Patronage in Rome at the Turn of the Seventeenth Century: The Case of Cardinal Montalto." *Studi musicali* 16, pp. 179–225.

Christiansen, K. 1982. "Marc' Antonio Pasqualini Crowned by Apollo." In *Notable Acquisitions, 1981–1982: The Metropolitan Museum of Art*, pp. 40–41. New York.

———. 1986. "Caravaggio and 'l'esempio davanti dal naturale.'" *Art Bulletin* 68, pp. 421–45.

———. 1988. "Appendix: Technical Report on 'The Cardsharps.'" *Burlington Magazine* 130, pp. 26–27.

———. 1990. "Some Observations on Caravaggio's Two Treatments of the 'Lute-Player.'" *Burlington Magazine* 132, pp. 21–26.

Cinotti, M. 1983. "Michelangelo Merisi detto il Caravaggio." In *I pittori bergamaschi: Il seicento*, vol. 1, pp. 205–641. Bergamo.

Cuzin, J.-P. 1977. *La Diseuse de bonne aventure de Caravage*. Les Dossiers du Département des Peintures, no. 13. Exhib. cat., Musée du Louvre, Paris.

Delaborde, J. 1888. *Marc-Antoine Raimondi*. Paris.

Dell'Acqua, G. A., and M. Cinotti. 1971. *Il Caravaggio e le sue grandi opere da San Luigi dei Francesi*. Milan.

De Rinaldis, A. 1935–36. "D'Arpino e Caravaggio." *Bollettino d'arte* 29 (1935–36), pp. 577–80.

Dézallier d'Argenville, A. J. 1762. *Abregé de la vie des plus fameux peintres avec leurs portraits gravés en taille-douce* Vol. 4. Paris.

Egan, P. 1961. "'Concert' Scenes in Musical Paintings of the Italian Renaissance." *Journal of the American Musicological Society* 14, no. 2, pp. 184–95.

Einstein, A. 1949. *The Italian Madrigal*. Princeton.

Fischer, P. 1972. *Music in Paintings of the Low Countries in the 16th and 17th Centuries*. Amsterdam.

Ford, T. 1984. "Andrea Sacchi's 'Apollo Crowning the Singer Marc' Antonio Pasqualini.'" *Early Music* 12, pp. 79–84.

Fortunati Pietrantonio, V. 1986. *Pittura bolognese del '500*. Vol. 2. Bologna.

Friedlaender, W. 1955. *Caravaggio Studies*. Princeton.

Frommel, C. L. 1971a. "Caravaggios Frühwerk und der Kardinel Francesco Maria del Monte." *Storia dell'arte* 9/10, pp. 5–52.

———. 1971b. "Caravaggio und seine Modelle." *Castrum Peregrini* 96, pp. 21–55.

Giusti Maccari, P. 1987. *Pietro Paolini, pittore lucchese, 1603–1681*. Lucca.

Giustiniani, V. ca. 1620 and ca. 1628 [1981]. *Discorsi sulle arti e sui mestieri*. Edited by A. Banti. Milan.

Greenwald, H. 1987. "Laurent de la Hire's *Allegory of Music*: Antiquity Updated." *RIdIM Newsletter* 12, no. 1, pp. 2–19.

Gregori, M. 1985. In *The Age of Caravaggio*. Exhib. cat., The Metropolitan Museum of Art, New York.

Gronau, G. 1936. *Documenti artistici urbinati*. Florence.

Guillet de Saint-Georges. 1854. "Mémoire historique des principaux ouvrages de M. de La Hire" (ca. 1691). In *Mémoires inédits sur la vie et les ouvrages des membres de l'Académie Royale de Peinture et de Sculpture . . .* , vol. 1. Paris.

Hammond, F. 1979. "Girolamo Frescobaldi and a Decade of Music in Casa Barberini, 1634–1643." *Analecta Musicologica* 19, pp. 94–124.

———. 1985. "More on Music in Casa Barberini." *Studi musicali* 14, pp. 235–61.

Haskell, F. 1963. *Patrons and Painters*. New York.

Haskell, F., and N. Penny. 1981. *Taste and the Antique: The Lure of Classical Sculpture, 1500–1900*. New Haven and London.

Heikamp, D. 1966. "La *Medusa* del Caravaggio e l'armatura dello scià Abbâs di Persia." *Paragone* 17, no. 199, pp. 62–76.

Heinz, G. 1972. "Realismus und Rhetorik im Werk des Bartolomeo Passarotti." *Jahrbuch der Kunsthistorisches Sammlungen in Wien* 68, pp. 153–69.

Hibbard, H. 1983. *Caravaggio*. New York.

Hollstein, F. W. H. 1955–80. *Dutch and Flemish Etchings, Engravings, and Woodcuts, ca. 1450–1700*. Vol. 11, 1955; vol. 15, 1964; vol. 16, 1974; vol. 21, 1980. Amsterdam.

Hoog, M. 1960. "Attributions anciennes à Valentin." *La Revue des arts: Musées de France* 6, pp. 267–78.

Houtzager, M. E., and E. Meijer. 1952. *Caravaggio en de Nederlanden: Catalogus*. Exhib. cat., Centraal Museum, Utrecht, and Koninklijk Museum voor Schone Kunsten, Antwerp.

Kirwin, W. C. 1971. "Addendum to Cardinal Francesco Maria del Monte's Inventory: The Date of the Sale of Various Notable Paintings." *Storia dell'arte* 9/10, pp. 53–56.

Lavin, M. 1975. *Seventeenth-Century Barberini Documents and Inventories of Art*. New York.

Levi D'Ancona, M. 1977. *The Garden of the Renaissance: Botanical Symbolism in Italian Painting*. Florence.

Lieure, J. 1929. *Jacques Callot*. 5 vols. Paris.

Longhi, R. 1913. "Due opere di Caravaggio." *L'arte* 16, pp. 161–64.

———. 1952. *Il Caravaggio*. Milan.

Lord, Louis. 1931. *A Translation of the Orpheus of Angelo Politian and the Aminta of Torquato Tasso; with an Introductory Essay on the Pastoral*. London.

Mahon, D. 1947. *Studies in Seicento Art and Theory*. London.

———. 1952. "Addenda to Caravaggio." *Burlington Magazine* 94, pp. 3–22.

———. 1988. "Fresh Light on Caravaggio's Earliest Period: His 'Cardsharps' Recovered." *Burlington Magazine* 130, pp. 11–25.

———. 1990. "The Singing 'Lute-Player' by Caravaggio from the Barberini Collection, Painted for Cardinal del Monte." *Burlington Magazine* 132, pp. 4–20.

Malvasia, C. C. 1678. *Felsina pittrice: Vite de' pittori bolognesi*. 2 vols. Bologna.

Mancini, G. ca. 1620 [1956]. *Considerazioni sulla pittura*. 2 vols. Edited by A. Marucchi. Rome.

van Mander, C. 1617 [1906]. *Das Leben der niederländischen und deutschen Maler des Carel van Mander*. Vol. 1. Translated by H. Floecke. Munich and Leipzig.

Manilli, J. 1650. *Villa Borghese fuori di Porta Pinciana descritta da Iacomo Manilli, romano guardaroba di detta villa*. Rome.

Marabottini Marabotti, A. 1963. "Il 'Naturalismo' di Pietro Paolini." In *Scritti di storia dell'arte in onore di Mario Salmi*, vol. 3, pp. 307–24. Rome.

Marani, P. 1987. *Leonardo e i leonardeschi a Brera*. Florence.

Mariette, P.-J. 1854–56. *Abecedario de Mariette et autres notes inédites de cet amateur sur les arts et les artistes, publiées par Ph. de Chennevières et A. de Montaiglon*. Vol. 3. Paris.

Marini, M. 1987. *Caravaggio: Michelangelo Merisi da Caravaggio "pictor praestantissimus."* Rome.

Martineau, J., and C. Hope, eds. 1984. *The Genius of Venice, 1500–1600*. Exhib. cat., Royal Academy of Arts, London. New York.

Meijer, B. 1972–73. "Harmony and Satire in the Work of Niccolo Frangipane: Problems in the Depiction of Music." *Simiolus* 6, pp. 94–112.

Merlo, G. 1987. In *Dopo Caravaggio: Bartolomeo Manfredi e la Manfrediana methodus*. Exhib. cat., Cremona. Milan.

de Mirimonde, A. P. 1963. "La Musique dans les oeuvres flamands du XVIIe siècle au Louvre." *La Revue du Louvre et des musées de France*, no. 4/5, pp. 167–83.

———. 1965a. "Les Sujets de musique chez les caravaggistes flamands." *Jaarboek; Koninklijk Museum voor Schone Kunsten, Antwerpen*, pp. 113–70.

———. 1965b. "The Musicians by Theodor Rombouts." *Register of the Museum of Art, the University of Kansas* 3, pp. 2–9.

———. 1966–67. "La Musique dans les allegories de l'amour." *Gazette des Beaux-Arts* 68, pp. 265–90; 69, pp. 319–46.

———. 1975. *L'Iconographie musicale sous les rois bourbons: La Musique dans les arts plastiques (XVIIe–XVIIIe siècles)*. Paris.

Moir, A. 1976. *Caravaggio and His Copyists*. New York.

de Montaiglon, A. 1856. *Catalogue raisonné de l'oeuvre de Claude Mellan*. Paris.

Murata, M. 1980. "Further Remarks on Pasqualini and the Music of *MAP*." *Analecta Musicologica* 19, pp. 125–45.

Nagler, G. K. 1841. *Neues allgemeines Künstler-Lexicon*. Vol. 10. Munich.

Orbaan, J. A. F. 1920. *Documenti sul Barocco in Roma*. Rome.

Ottani, A. 1963. "Per un caravaggesco toscano: Pietro Paolini (1603–1681)." *Arte antica e moderna* 21, pp. 19–34.

———. 1965. "Integrazioni al catalogo del Paolini." *Arte antica e moderna* 30, pp. 181–88.

Ottino della Chiesa, A. 1967. *L'opera completa del Caravaggio*. Milan.

Parks, N. R. 1985. "On Caravaggio's 'Dormition of the Virgin' and Its Setting." *Burlington Magazine* 127, pp. 438–48.

Petrarch, F. 1946. *Sonnets and Songs*. Translated by A. M. Armi. New York.

Posner, D. 1971a. *Annibale Carracci: A Study in the Reform of Italian Painting Around 1590*. New York.

———. 1971b. "Caravaggio's Homo-erotic Early Works." *Art Quarterly* 34, pp. 301–24.

Préaud, M. 1988. *Bibliothèque Nationale; Inventaire du fonds français: Graveurs du XVIIe siècle*. Vol. 17, *Claude Mellan*. Paris.

von Ramdohr, F. W. B. 1787. *Ueber Mahlerei und Bildhauerarbeit in Rom fuer Liebhaber des Schoenen in der Kunst*. Leipzig.

Ratti, C. G. 1780. *Instruzione di quanto puo' vedersi di più bello in Genova in pittura, scultura ed architettura*. 2d ed. Genoa.

Reese, G. 1959. *Music in the Renaissance*. New York.

Ripa, C. 1603. *Iconologia...*. Rome.

———. 1644 [1976]. *Iconologie...*. Translated by Jean Baudouin. Vol. 29 of *The Renaissance and the Gods*. New York and London.

Rosci, M. 1971. *Baschenis Bettera e Co.: Produzione e mercato della natura morta del seicento in Italia*. Milan.

———. 1985. "Evaristo Baschenis." In *I pittori bergamaschi: Il seicento*, vol. 3, pp. 1–149. Bergamo.

Rosenberg, P., and J. Thuillier. 1988. *Laurent de la Hyre, 1606–1656*. Exhib. cat., Musée de Grenoble, Musée de Rennes, and Musée des Beaux-Arts, Bordeaux. Geneva.

Rosselli, J. 1988. "The Castrati as a Professional Group and a Social Phenomenon, 1550–1850." *Acta Musicologica* 60, pp. 143–79.

Salerno, L. 1960. "The Picture Gallery of Vincenzo Giustiniani." *Burlington Magazine* 102, pp. 21–27, 93–104, 135–48.

———. 1984. *La natura morta italiana, 1560–1805: Still Life Painting in Italy*. Rome.

von Sandrart, J. 1675 [1925]. *Academie der Bau-, Bild-, und Mahlerey-Künste*. Edited by A. R. Peltzer. Munich.

von Schneider, A. 1966. *I seguaci del Caravaggio nei Paesi Bassi*. Milan.

Shapley, F. R. 1973. *Paintings from the Samuel H. Kress Collection: Italian Schools, XVI–XVIII Century*. London.

———. 1979. *Catalogue of the Italian Paintings*. 2 vols. National Gallery of Art, Washington, D.C.

Shearman, J. 1983. *The Early Italian Pictures in the Collection of Her Majesty the Queen*. Cambridge.

Slim, H. C. 1985. "Musical Inscriptions in Paintings by Caravaggio and His Followers." In Anne Shapiro, ed., *Music and Context: Essays in Honor of John Milton Ward*, pp. 241–63. Cambridge, Mass.

Spear, R. 1971. *Caravaggio and His Followers*. Exhib. cat., Cleveland Museum of Art.

Spezzaferro, L. 1971. "La cultura del Cardinal del Monte e il primo tempo di Caravaggio." *Storia dell'arte* 9/10, pp. 57–92.

———. 1974. "The Documentary Findings: Ottavio Costa as a Patron of Caravaggio." *Burlington Magazine* 116, pp. 579–86.

Spike, J. 1983. *Italian Still Life Paintings from Three Centuries*. Exhib. cat., National Academy of Design, New York, Philbrook Art Center, Tulsa, and Dayton Art Institute, Ohio. Florence.

Sutherland Harris, A. 1977. *Andrea Sacchi*. Princeton.

Tallemant des Réaux, G. 1961. *Historiettes*. Edited by A. Adam. Vol. 2. Dijon.

Tassi, F. M. 1793. *Vite de' pittori, scultori e architetti bergamaschi*. Vol. 1. Bergamo.

van Thiel, P. J. J. 1967–68. "Marriage Symbolism in a Musical Party by Jan Miense Molenaar." *Simiolus* 2, no. 2, pp. 91–99.

Tittoni Monti, E. 1989. "La *Buona Ventura* di Caravaggio: Note e precisioni in margine al restauro." *Quaderni di Palazzo Venezia*, no. 6, pp. 126–50.

Van der Meer, J. H. 1978. "A Contribution to the History of the Clavicytherium." *Early Music* 6, pp. 247–59.

Vasari, G. 1568 [1906]. *Le vite de' più eccellenti pittori, scultori ed architettori scritte da Giorgio Vasari, pittore aretino, con nuove annotazioni e commenti di Gaetano Milanesi.* 9 vols. Florence.

Vecellio, C. 1590. *De gli habiti antichi, et moderni.* Venice.

Vertova, L. 1980. "Bernardino Licinio." In *I pittori bergamaschi: Il cinquecento*, vol. 1, pp. 373–441. Bergamo.

Volpe, C. 1973. "Una proposta per Giovanni Battista Crescenzi." *Paragone* 275, pp. 25–36.

Weigert, R.-A. 1951–54. *Bibliothèque nationale; Inventaire du fonds français: Graveurs du XVIIe siècle.* Vols. 2, 3. Paris.

Wiemers, M. 1986. "Caravaggios 'Amor Vincitore' im Urteil eines Romfahrers um 1650." *Pantheon* 44, pp. 59–61.

Wind, B. 1974. "'Pitture Ridicole': Some Late Cinquecento Comic Genre Paintings." *Storia dell'arte* 20, pp. 25–35.

Wolfe, K. 1985. "Caravaggio: Another 'Lute Player.'" *Burlington Magazine* 127, pp. 451–52.

CONCENTVM INTER SE, ET DISCRIMINA GRATA SONORVM
AVRE ERVDITA DEPREHENDIT MVSICA.

Fig. 42. Cornelis Cort (after Frans Floris), *Music*. The Metropolitan Museum of Art.

Lenders to the Exhibition

Italy
Rome: Pinacoteca Capitolina
Private collection

Soviet Union
Leningrad: State Hermitage Museum

United States
Boston: Museum of Fine Arts
Dallas: Dallas Museum of Art
Fort Worth: Kimbell Art Museum
Malibu: J. Paul Getty Museum
New York: Private collection
Philadelphia: John G. Johnson Collection,
* Philadelphia Museum of Art*
Salt Lake City: University of Utah
Washington, D.C.: National Gallery of Art